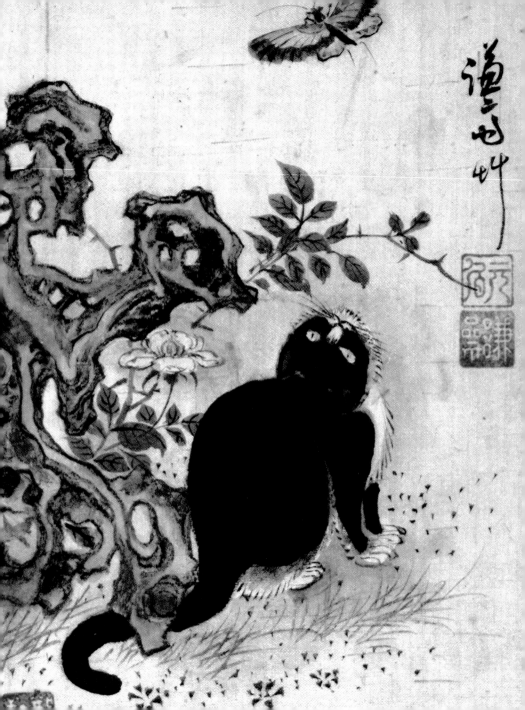

Illustration through the Ages

THE BRITISH LIBRARY

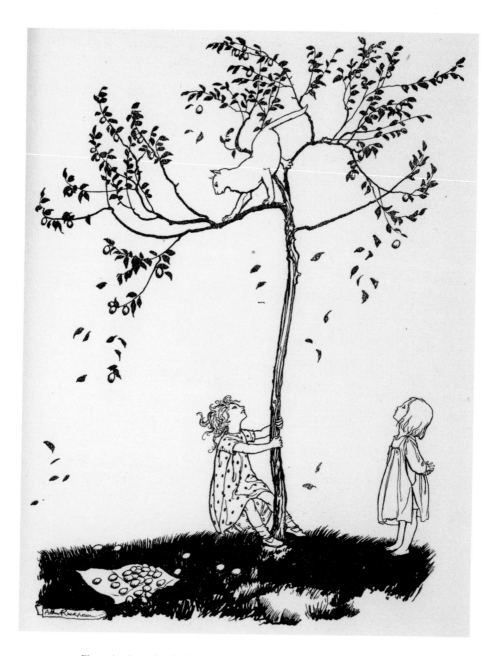

Illustration by Arthur Rackham from *Mother Goose, the Old Nursery Rhymes*, 1913.

A Black Cat Holiday by Charles Robinson from *The Black Cat Book* by W Copeland, 1905.

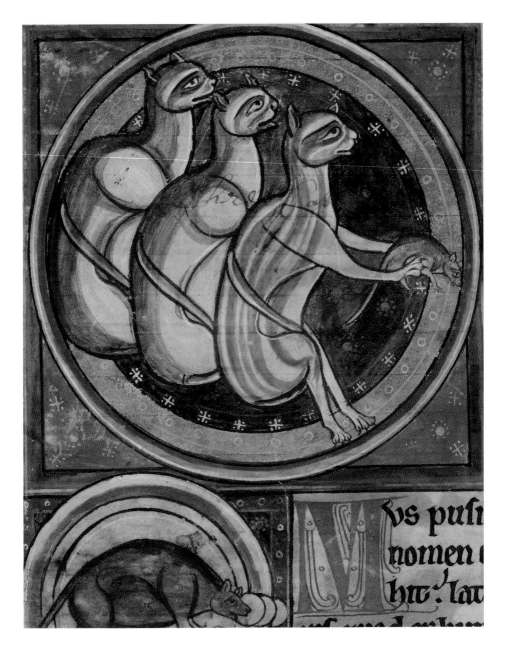

Three cats and a mouse from an English Bestiary, early thirteenth century.

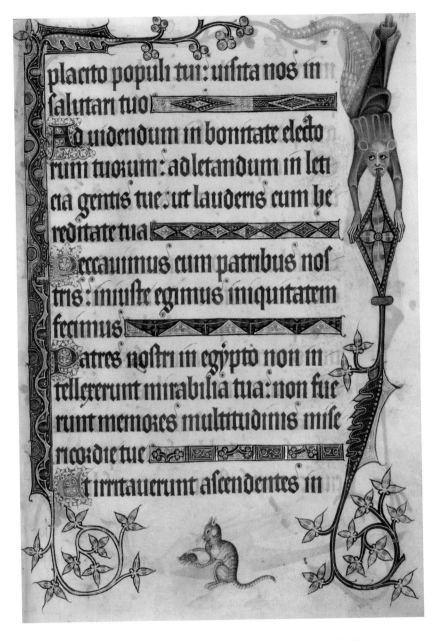

placeto populi tui: uisita nos in
salutari tuo.

Ad uidendum in bonitate electo
rum tuorum: ad letandum in leti
cia gentis tue: ut lauderis cum he
reditate tua.

Peccauimus cum patribus nos
tris: iniuste egimus iniquitatem
fecimus.

Patres nostri in egypto non in
tellexerunt mirabilia tua: non fue
runt memores multitudinis mise
ricordie tue.

Et irritauerunt ascendentes in

Cat with a mouse in its paws from the Luttrell Psalter, c. 1325–35.

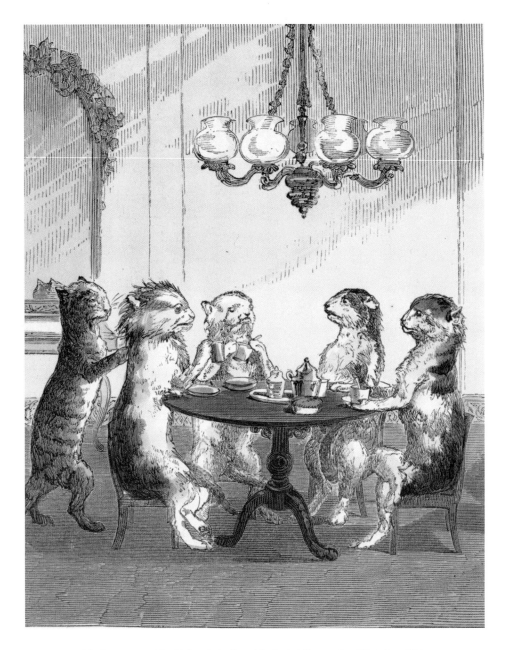

The kittens at tea – Miss Paulina singing from *The Comical Creatures from Wurtemberg*, 1851.

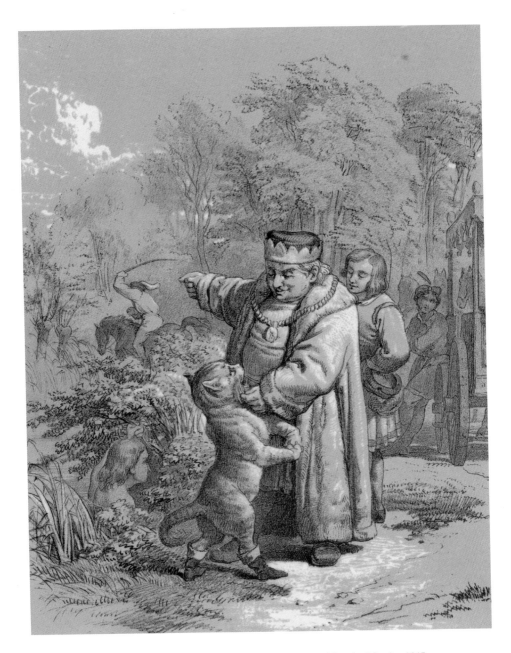

Puss in Boots by Otto Speckter from *Puss in Boots and the Marquis of Carabas*, 1847.

'Once cats were all wild, but afterward
they retired to houses.'

Edward Topsell

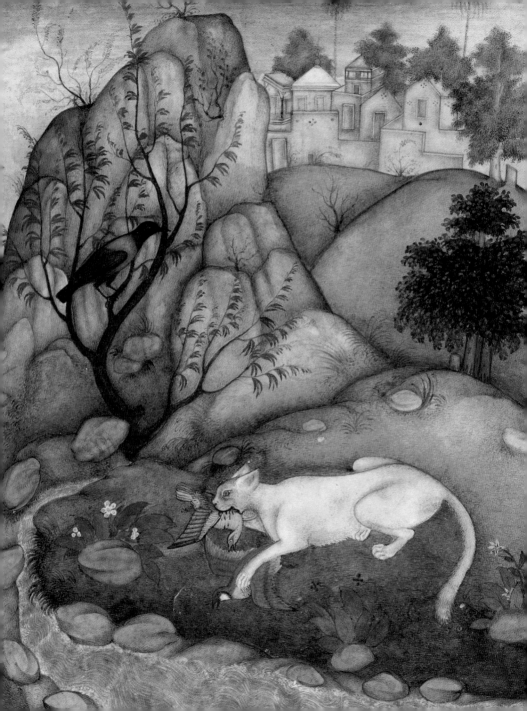

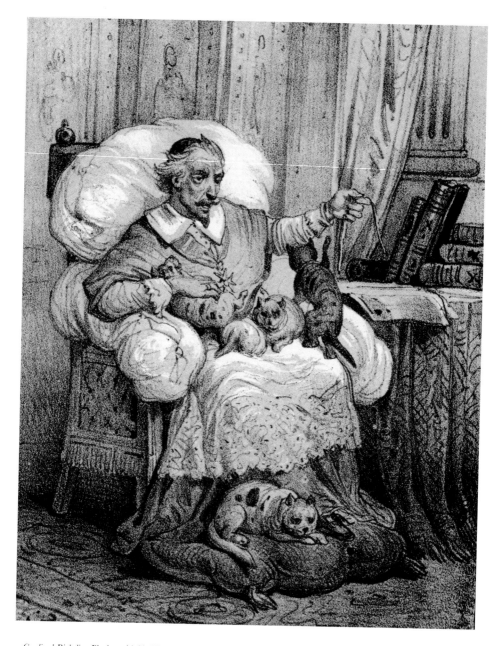

Cardinal Richelieu Playing with his Kittens by Victor Adam from *Les Animaux Historiques* by Ortaire Fournier, 1845.

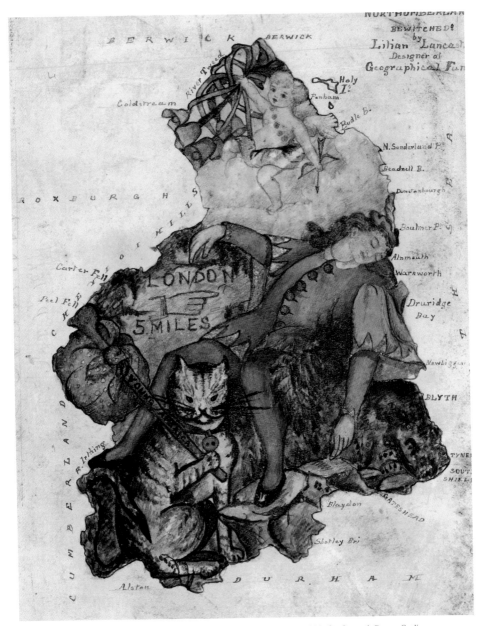

The County of Northumberland as a picture of Dick Whittington and his Cat from *A Correct Outline of the County of Northumberland* by Lilian Lancaster, 1869.

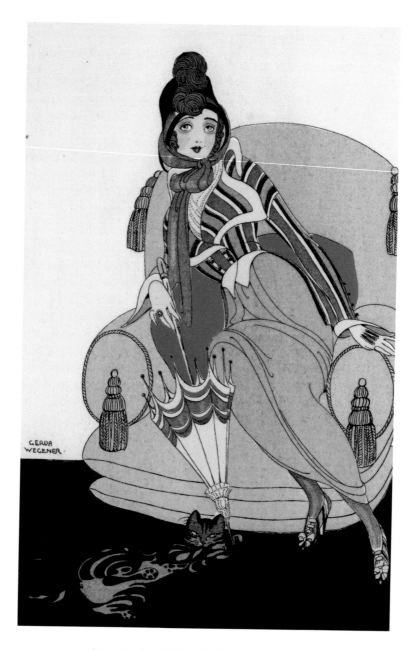

Illustration from *Le Journal des Dames et des Modes*, 1914.

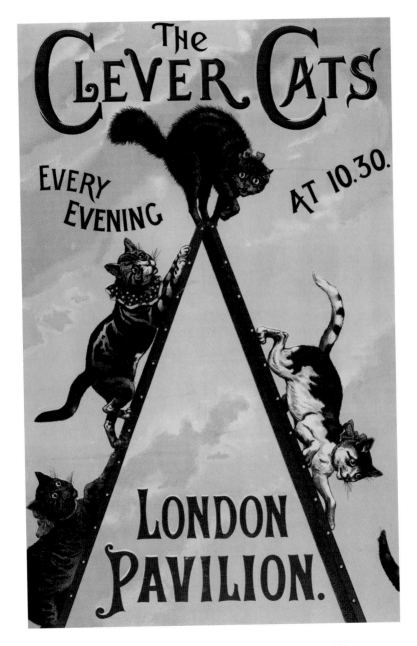

Poster for *The Clever Cats* at the London Pavilion, Piccadilly, 1888.

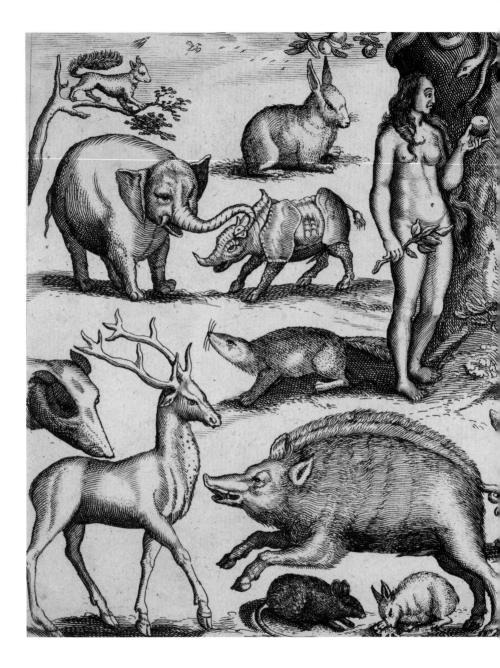

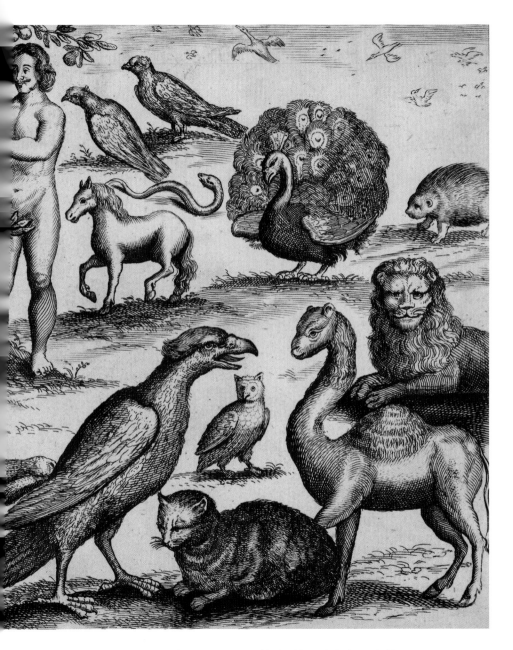

A Cat in the Garden of Eden from *A booke of Beasts liuely drawne*, 1560.

'To respect the cat is the beginning
of the aesthetic sense.'

Erasmus Darwin

A member of the cat family, possibly a tiger, from
The Dream Manual, Nepal, eighteenth century.

— **18** —

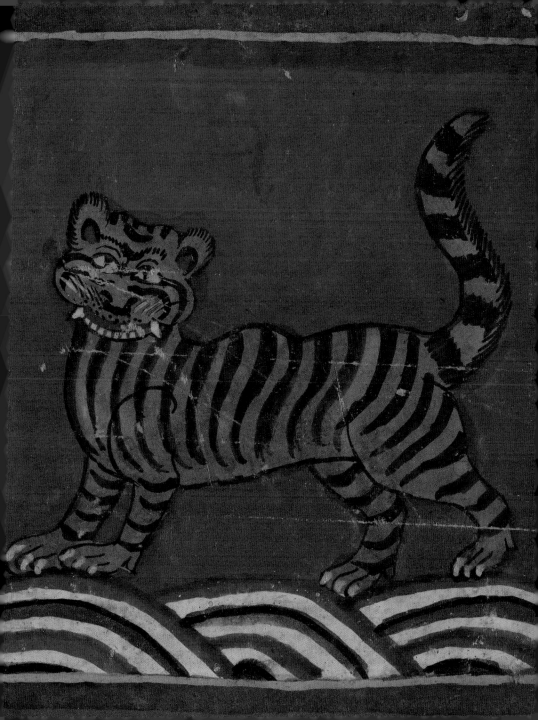

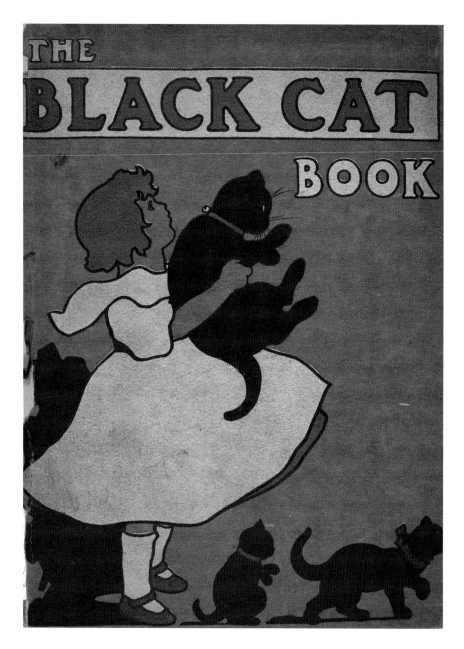

Front cover of *The Black Cat Book* by W Copeland, illustrated by Charles Robinson, 1905.

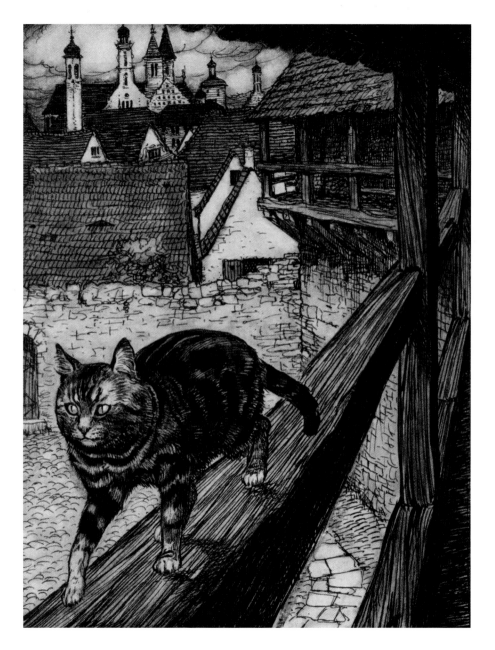

The Cat and the Mouse in Partnership by Arthur Rackham from *The Fairy Tales of the Bros. Grimm*, 1909.

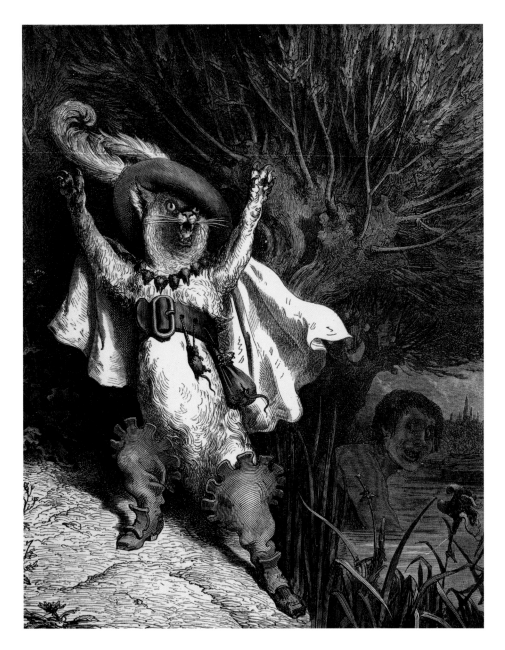

Puss in Boots by Gustave Doré from *Fairy Tales Told Again*, 1872.

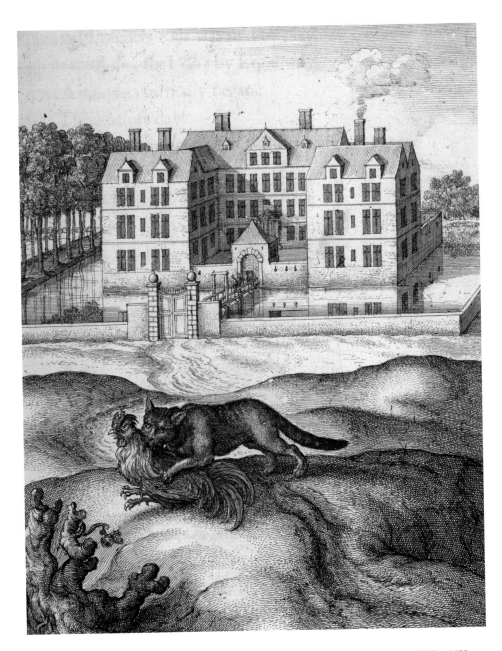

The Cat and the Cock by Wenceslas Hollar from *The Fables of Aesop paraphras'd in verse* by John Ogilby, 1675.

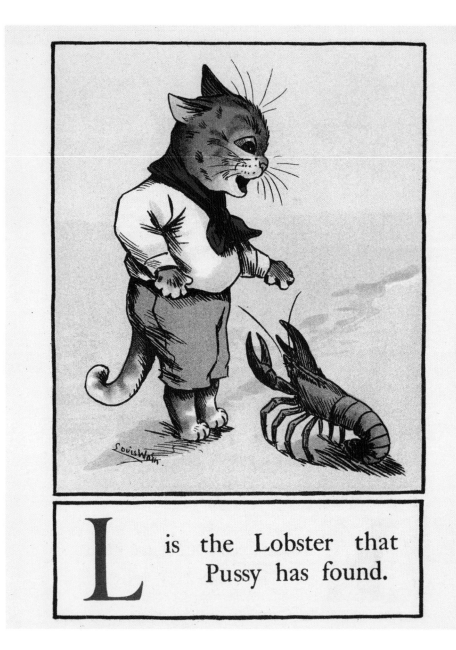

L is the Lobster that Pussy has found.

L is the Lobster by Louis Wain from *A Cat Alphabet and Picture Book for Little Folk*, 1914.

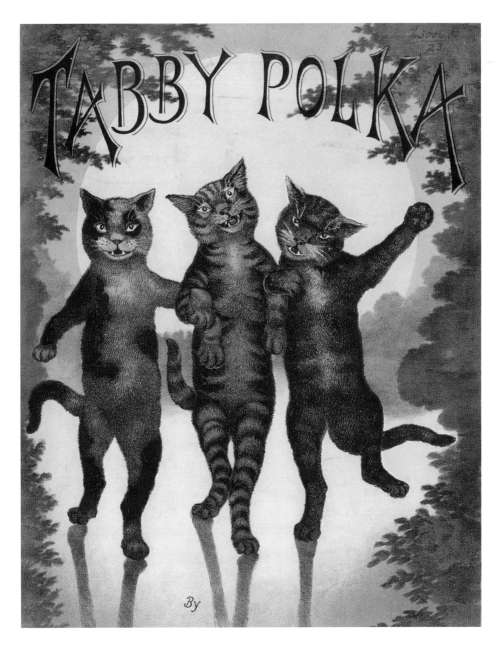

Front cover illustration by Louis Wain for *The Tabby Polka* by P Bucalossi, 1865.

'What greater gift than the love of a cat.'

Charles Dickens

Jack and Jill Resting on their Way to London by Cecil Aldin from
Jack and Jill by May Byron, 1914.

— 27 —

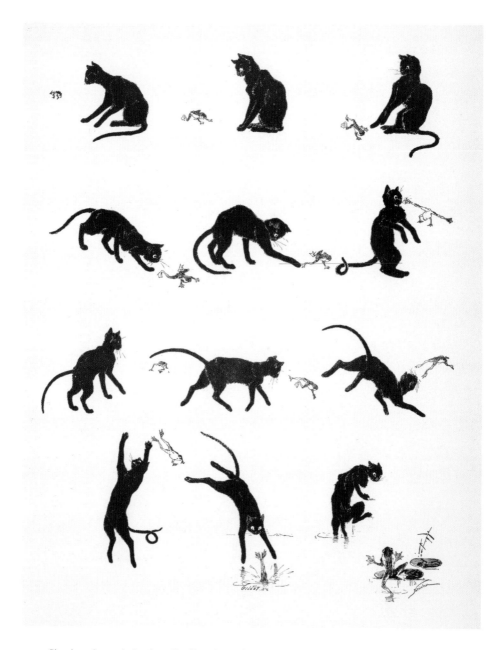

Sketches of cats playing from *Des Chats, Images Sans Paroles* by Théophile-Alexandre Steinlen, 1897.

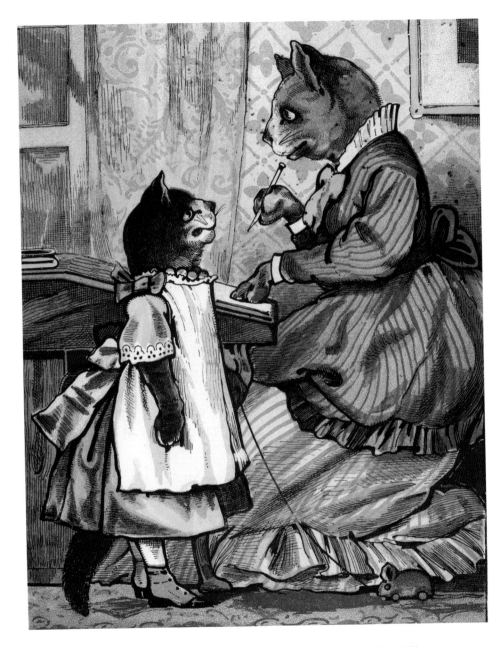

Mrs Mouser Writing the Invitations. Illustration from *Miss Mouser's Tea Party*, 1876.

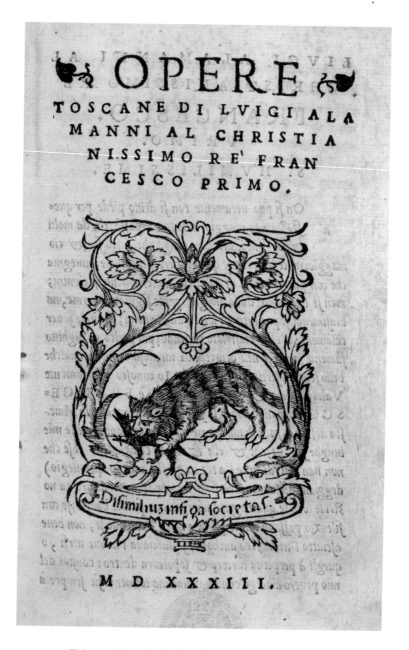

Title page illustration for *Opere Toscane*, Luigi Alamanni, 1533.

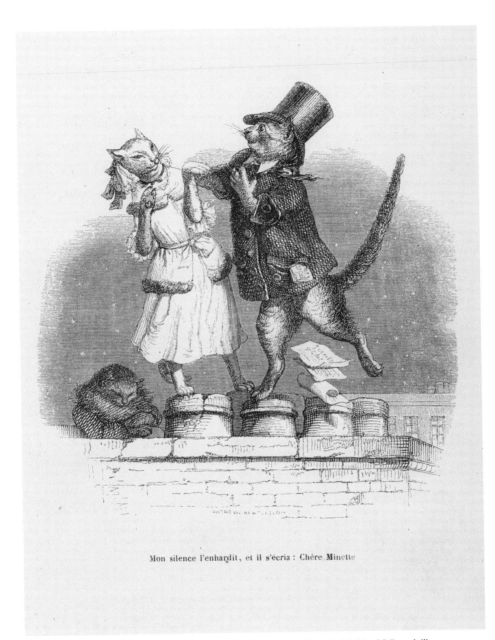

Mon silence l'enhardit, et il s'écria : Chère Minette

Cries of the Heart of an English Cat ('*Peines de Coeur d'une Chatte Anglaise*') by J J Grandville
from *Scènes de la vie privée et publique des animaux* by P J Stahl, 1842.

Up and down, through the shed, over the garden wall, with fur bristling, and tails up, the mad race went.

The rat was fleet of foot, and led the race with the cat family close upon his heels.

Over hills, and down dale, away! away! away! Through the woods, over the valleys they sped. Never a chase was known like this.

Finally, they came to the gates of The Glad Lands, where all animals dwell in peace together and the race was over.

The rat shook hands with Mrs. Mouzer and the three little kittens, while the Calico Kangaroo pinned a medal on the breast of the rat for winning the race.

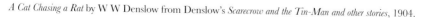

A Cat Chasing a Rat by W W Denslow from Denslow's *Scarecrow and the Tin-Man and other stories*, 1904.

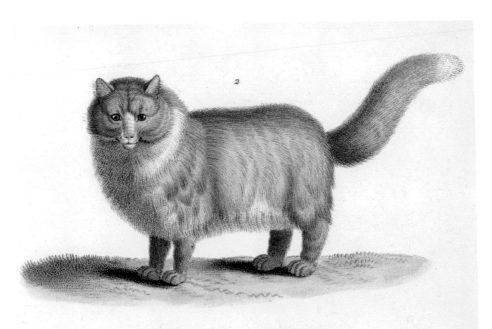

1. le Chat Loup Cervier. 2. le Chat d'Angora.

el. *J.B.*

Angora Cat by Nicolas and Jean-Baptiste Huet from the *Collection de mammifères du Museum d'Histoire Naturelle*, 1808.

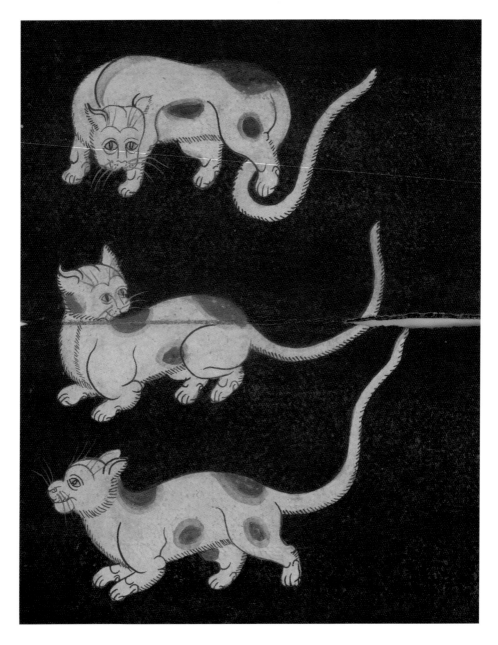

Illustration from a Thai manuscript.

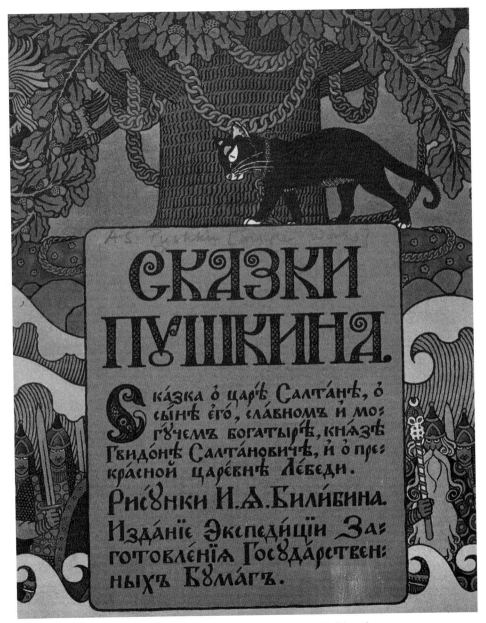

Title page illustration by Ivan Bilibin for a 1905 edition of
The Tale of Tsar Saltan by Alexander Pushkin, 1831.

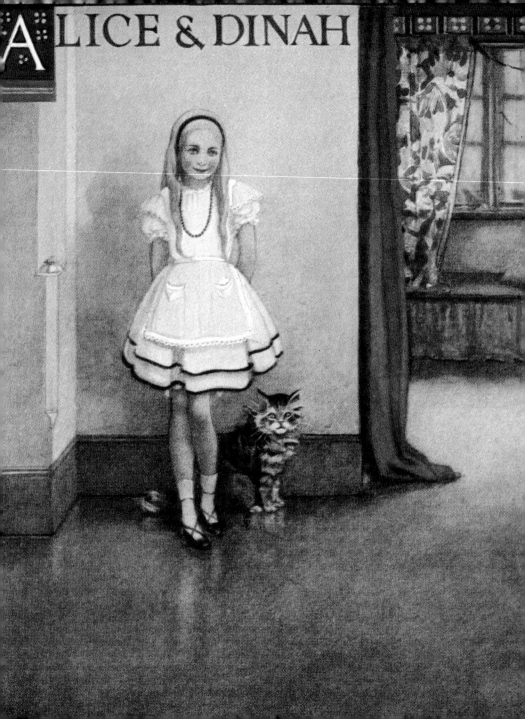

ALICE & DINAH

'In nine lifetimes, you'll never know
as much about your cat as your cat
knows about you.'

Michel de Montaigne

Alice and Dinah by Gwynedd Hudson from *Alice's Adventures in Wonderland*
by Lewis Carroll, edition of 1922.

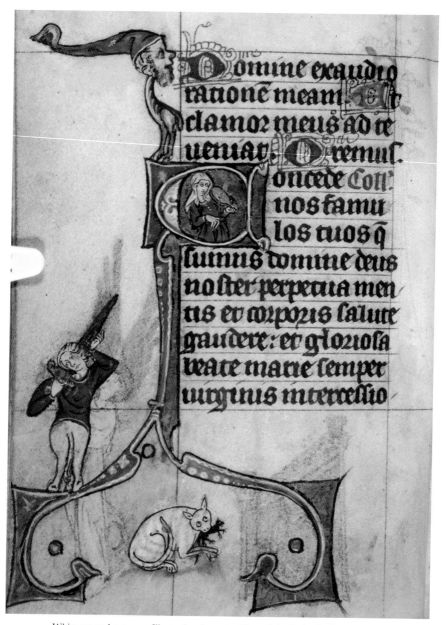

White cat and a mouse. Illustration from the *Hours of the Virgin*, the Netherlands, thirteenth to fourteenth century.

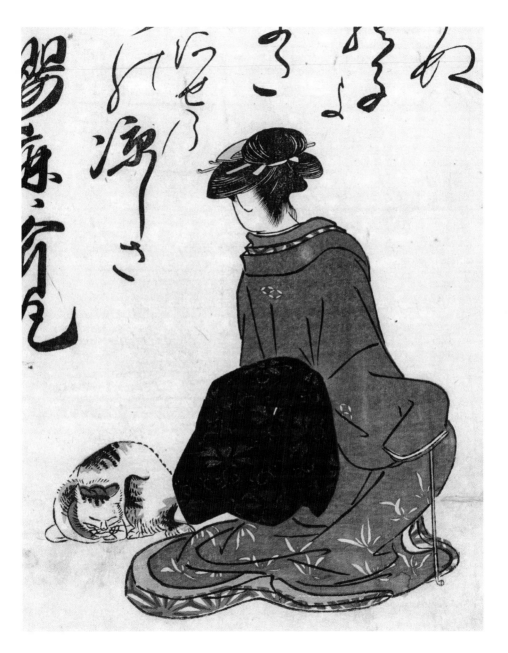

A Poetess and her Cat by Utagawa Toyohiro 1793.

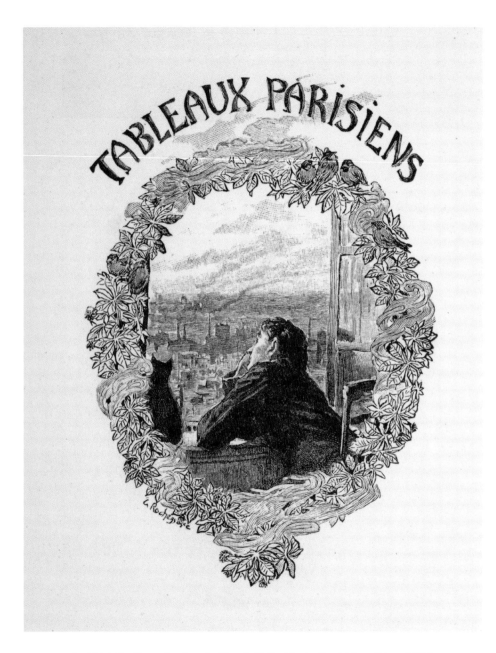

Baudelaire's Cat. Illustration from *Les Fleurs du Mal* by Charles Baudelaire, edition of 1917.

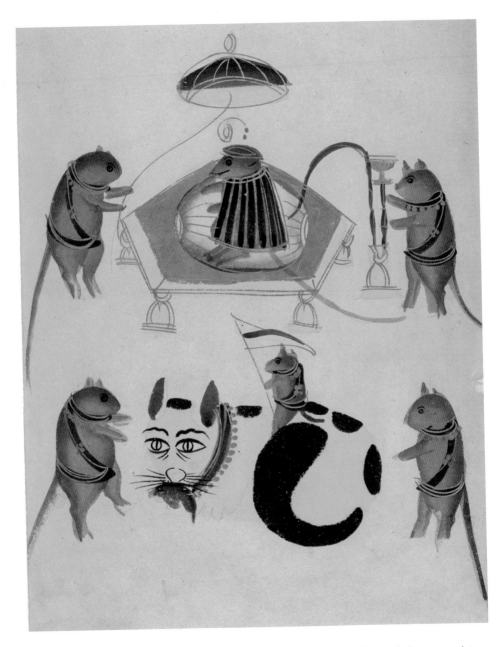

A musk-rat raja sits on a throne while another rides a tame cat. Illustrations from an Indian manuscript.

How many cats are at the saucer? How many cats are here? How many c
What are these 2 cats doing? How many feet has a cat? Has it a round

Count 1 cat, 2 cats, 3 cats! How many Cats are running? How many re
covered with wool? Of what colour are these cats? How does the cat cry?

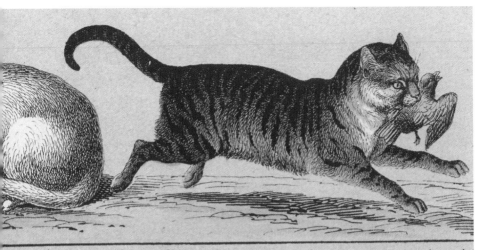

2 cats and 1 cat? How many cats are running? How many remain quiet
ted head? (2 and 1 make 3; 1 from 3 & 2 remain.)

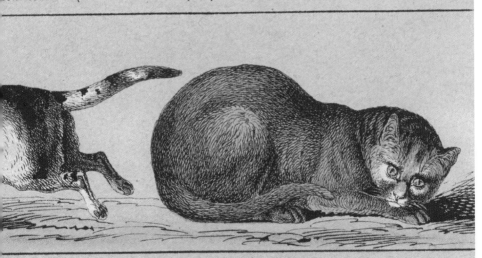

iet? What have the cats in their paws? What in their mouths? Are cat
at use is it? (2 from 3 & 1 remains) 3 is 1 & 2 or 2 & 1 or 1 & 1 & 1

Illustrations from *The New Picture Book* by Niklaus Bohny, 1877.

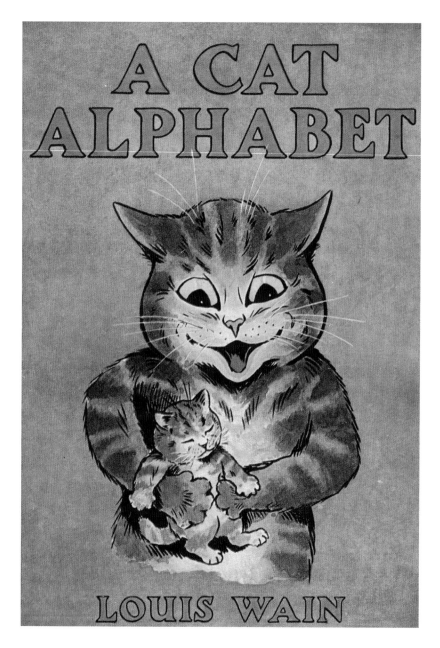

Front cover illustration by Louis Wain for *A Cat Alphabet and Picture Book for Little Folk*, 1914.

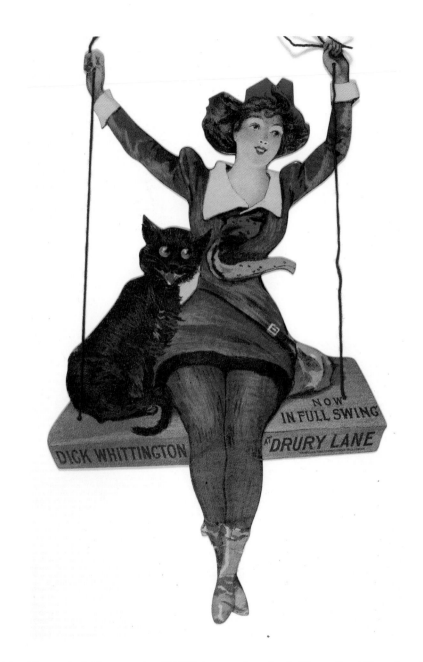

Advertising novelty for the pantomime *Dick Whittington*, performed at the Theatre Royal, Drury Lane, 1894–5.

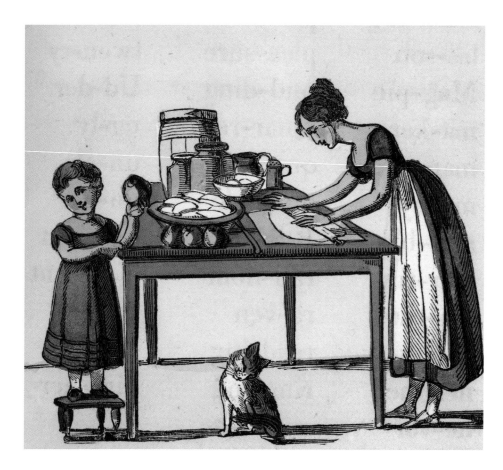

A was an Apple and put in a Pie from *The Alphabet of Goody Two Shoes*, 1822.

Checking the Milk Jug from *The White Kitten Book*, written and illustrated by Cecil Aldin, 1909.

nedictus fructus

is tui. añ. Sicut

myrra. Psalmus d

di enarrant

gloriam dei

opera manuum

'Thousands of years ago, cats were worshipped as gods. Cats have never forgotten this.'

Anonymous

A cat's head in a border. Illustration from the Sforza Hours, *c.* 1490.

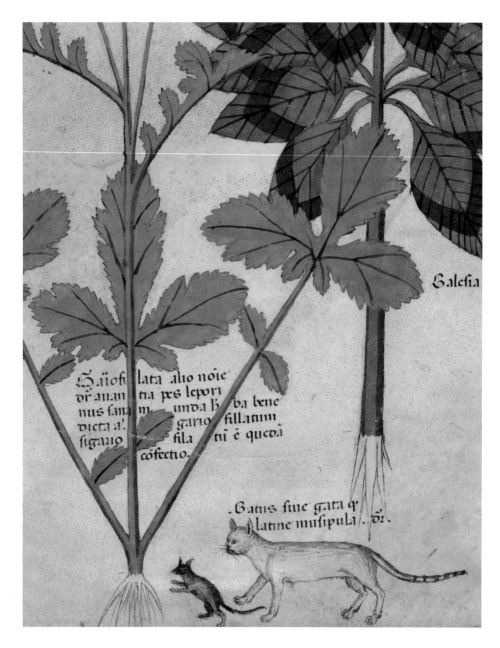

Galefia

 Gaiiofi lata alio noie
dr auam ta pes lepori
nus fana m umda h ba bene
dicta a'. gario fillatim
sigano fila ti e queoa
cofectio.

. Batus fue gata q'
latine mufipula . or.

Cat following a mouse. Illustration from an Italian Herbal, *c.* 1444.

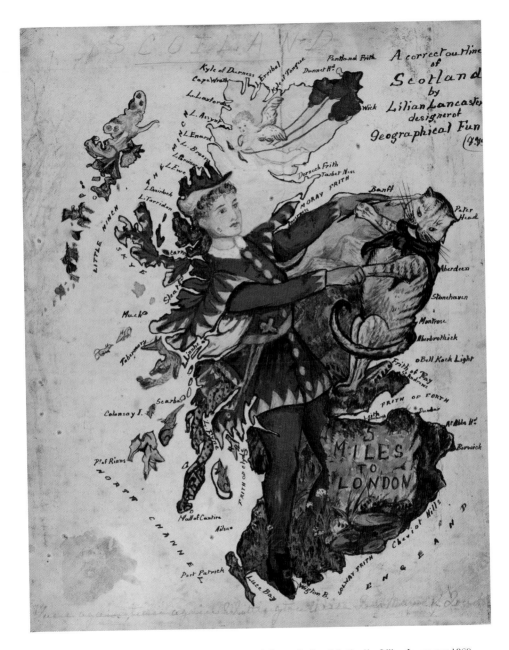

Map of Scotland as Dick Whittington and his Cat from *A Correct Outline of Scotland* by Lilian Lancaster, 1869.

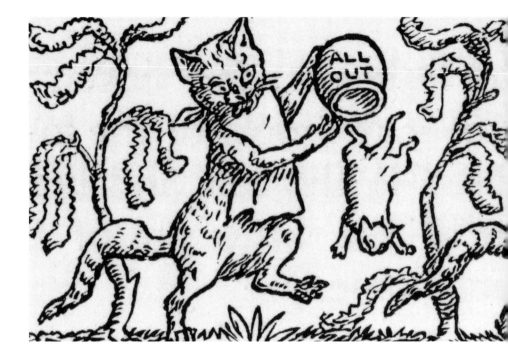

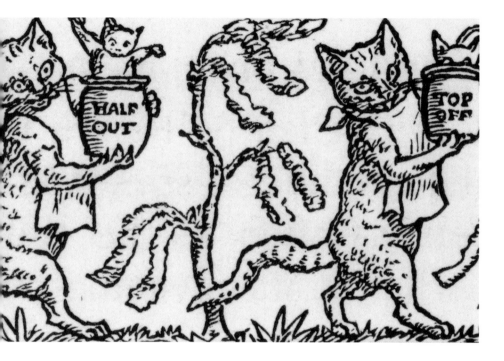

The Cat and the Mouse in Partnership by Walter Crane. Illustration from *Household Stories,*
from the collection of the Bros. Grimm, 1882.

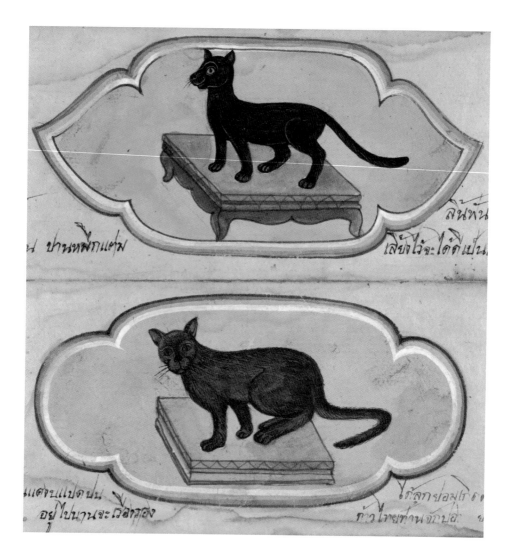

Siamese Cats from a Thai manuscript of the nineteenth century.

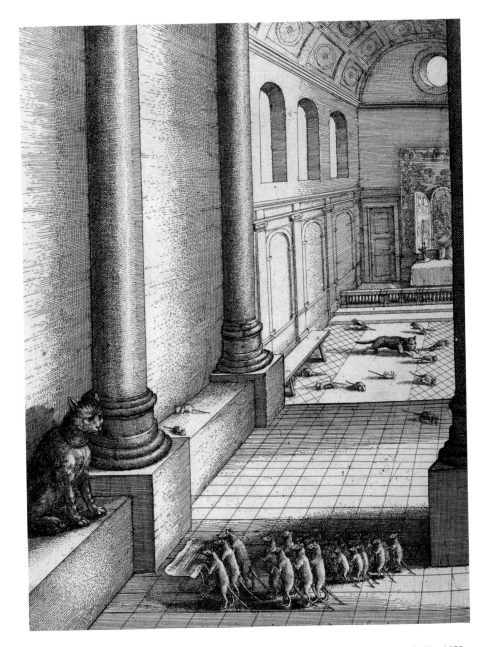

The Cat and the Mice by Wenceslas Hollar from *The Fables of Aesop paraphras'd in verse* by John Ogilby, 1675.

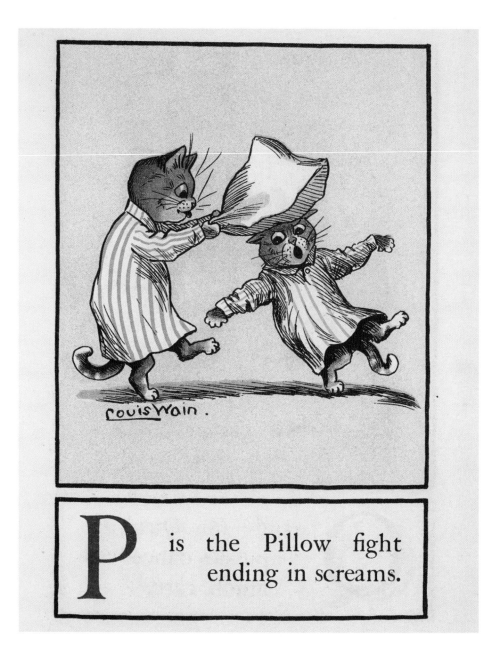

P is the Pillow fight ending in screams.

P is the Pillow fight by Louis Wain from *A Cat Alphabet and Picture Book for Little Folk*, 1914.

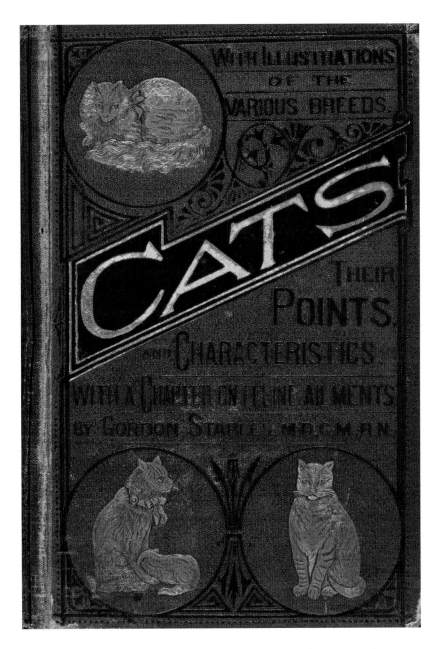

Cover illustration for *Cats: Their Points and Characteristics* by W Gordon Stables, 1876.

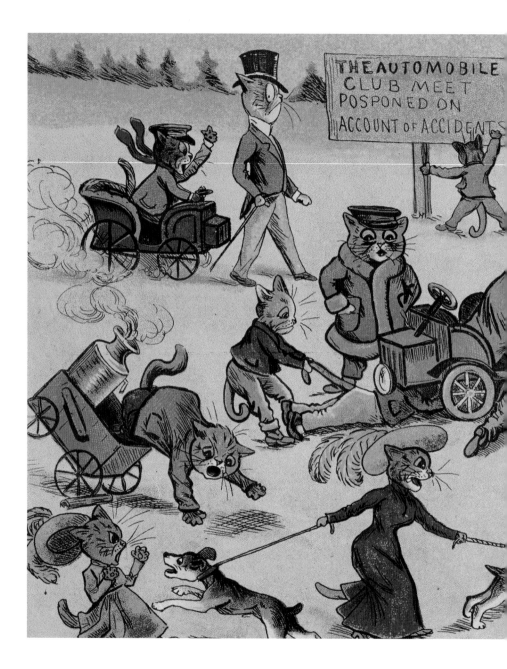

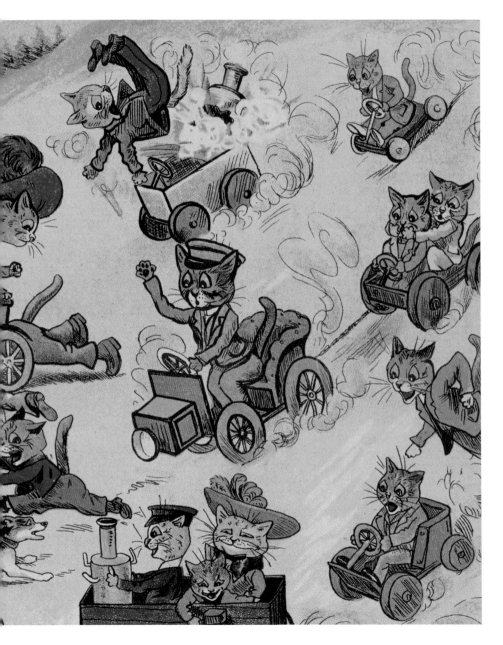

The Automobile Club Meet by Louis Wain from *Fun in Catland*, 1919.

'I believe cats to be spirits come to earth.
A cat, I am sure, could walk on a cloud
without coming through.'

Jules Verne

The Boy who Drew Cats. Illustration from *Japanese Fairy Tale* series, 1905.

— 60 —

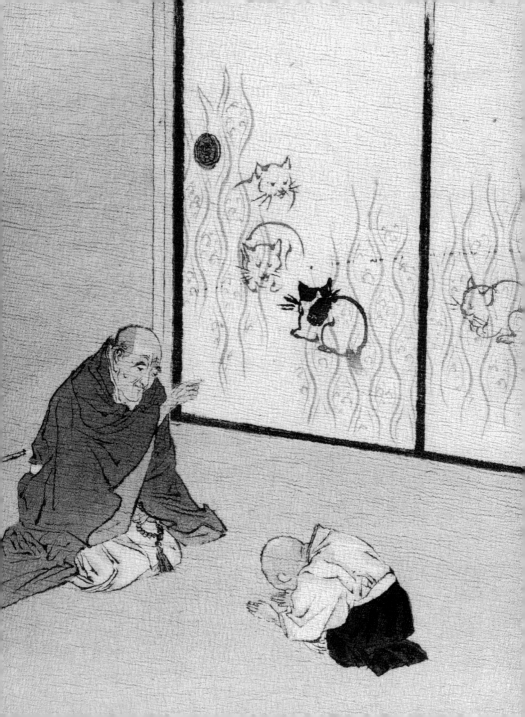

Cat Sat on the Mat by Walter Crane from *The Golden Primer* by John Meiklejohn, 1884.

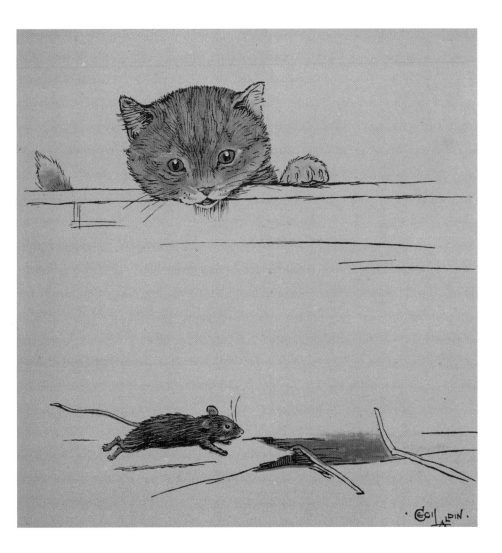

Watching a Mouse from *The White Kitten Book*, written and illustrated by Cecil Aldin, 1909.

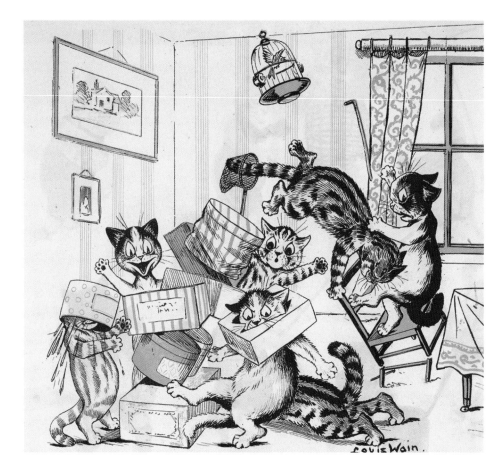

Naughty, Naughty Pussies by Louis Wain from *Fun in Catland*, 1919.

The Cheshire Cat by Gwynedd Hudson from *Alice's Adventures in Wonderland* by Lewis Carroll, edition of 1922.

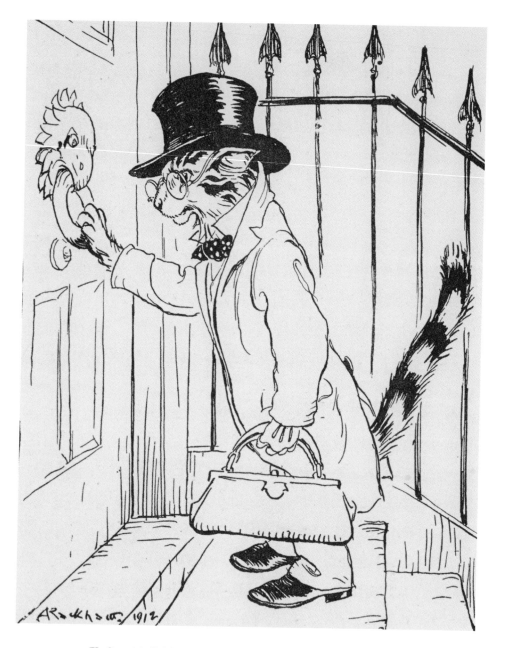

The Cat and the Birds by Arthur Rackham from *Aesop's Fables*, edition of 1936.

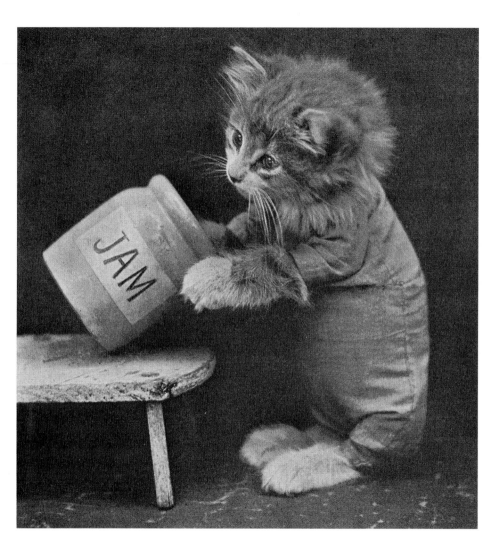

Checking the Jam from *Four Little Kittens*, written and illustrated by Henry Whittier Frees, 1934.

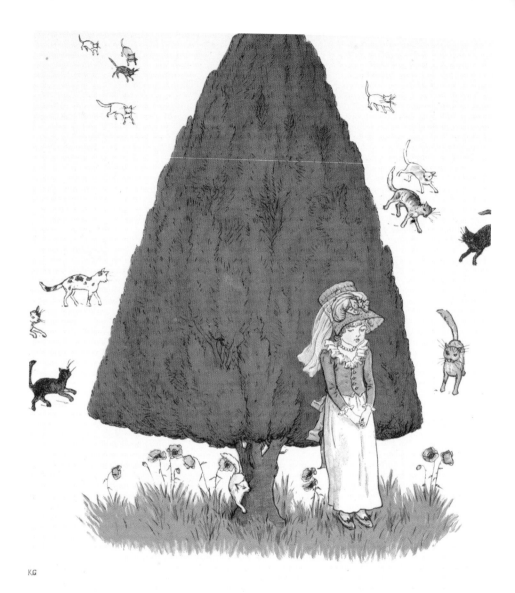

THE CATS HAVE COME TO TEA.

The Cats Have Come to Tea. Illustration by Kate Greenaway from *Marigold Garden*, 1885.

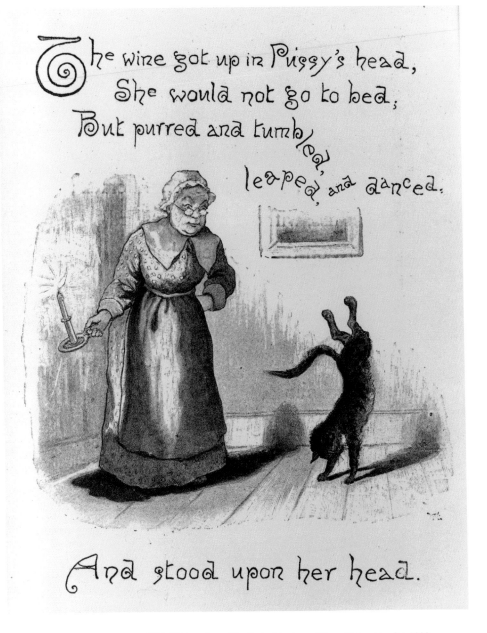

The wine got up in Pussy's head,
She would not go to bed;
But purred and tumbled,
leaped, and danced.

And stood upon her head.

Dame Trot and her Cat by Will Gibbons from *The Comic Adventures of Dame Trot and her Cat*, 1888.

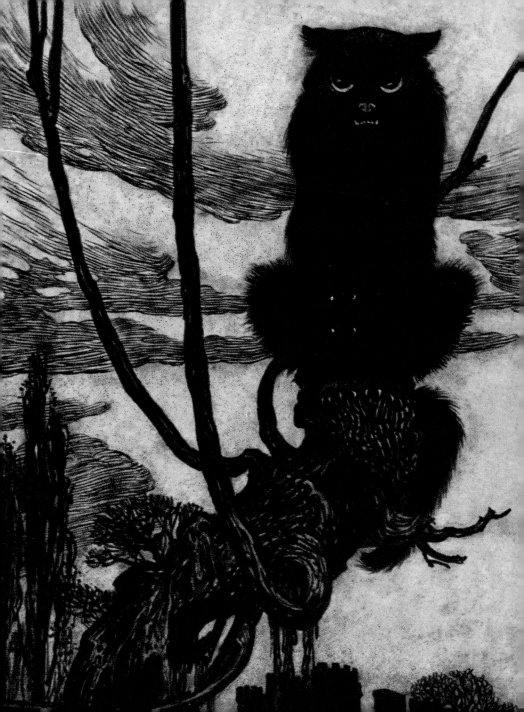

'When my cats aren't happy, I'm not happy. Not because I care about their mood, but because I know they're just sitting there thinking up ways to get even.'

Percy Bysshe Shelley

Black Cat from *Jorinder and Joringel*. Illustration by Arthur Rackham from *Grimms' Fairy Tales*, 1925.

— 71 —

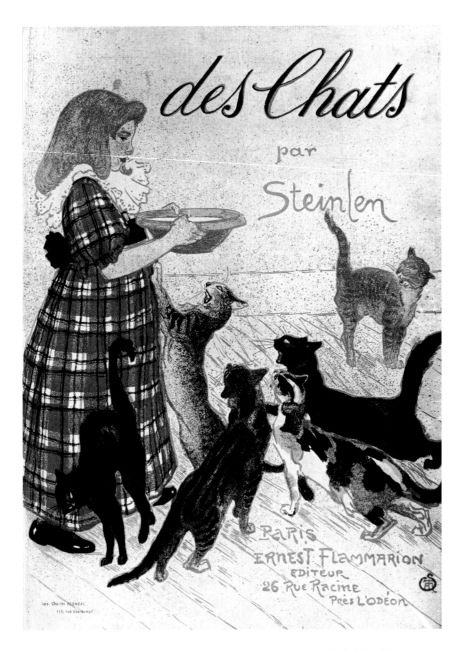

Front cover of *Des Chats, Images Sans Paroles* by Théophile-Alexandre Steinlen, 1897.

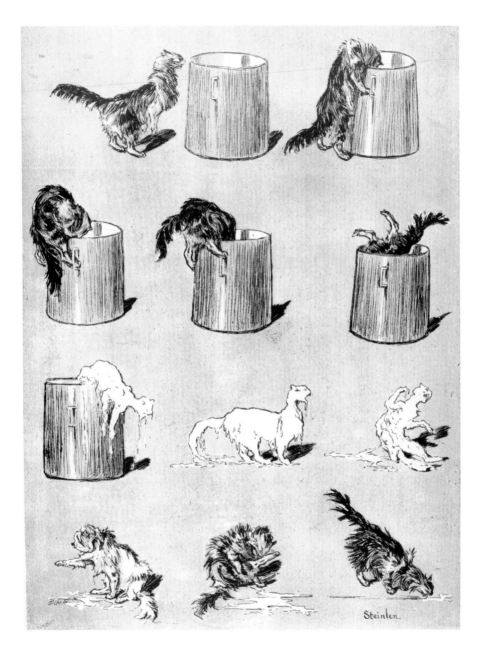

Sketches of cats from *Des Chats, Images Sans Paroles* by Théophile-Alexandre Steinlen, 1897.

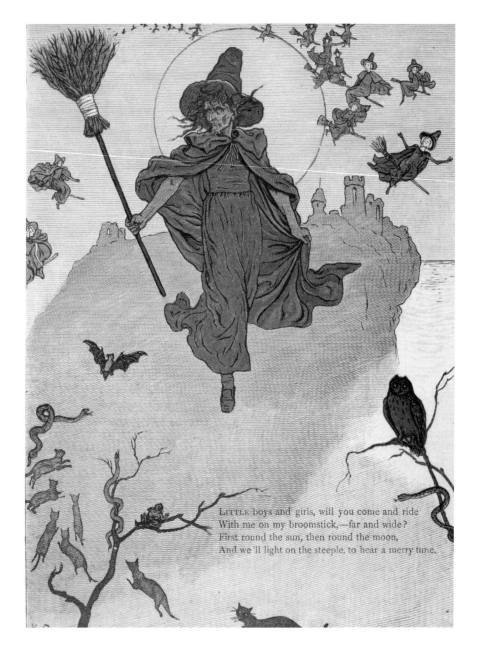

LITTLE boys and girls, will you come and ride
With me on my broomstick,—far and wide?
First round the sun, then round the moon,
And we'll light on the steeple, to hear a merry tune.

Invitation to a Broomstick Ride from *Under the Window. Pictures and Rhymes for Children* by Kate Greenaway, 1897.

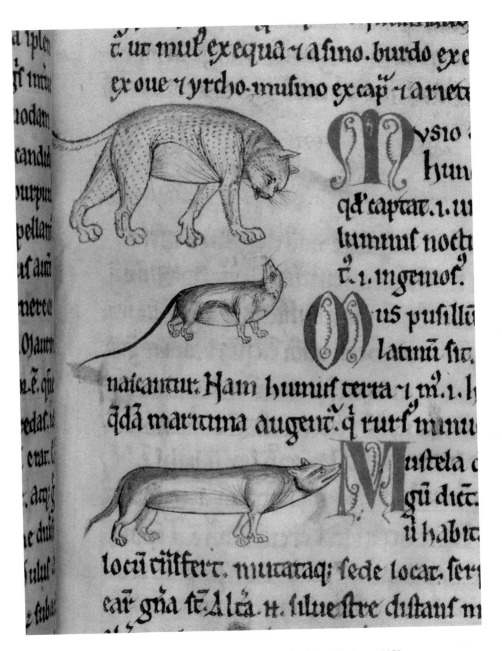

t̃. ut mul' ex equa ꞇ afino. burdo ex e
ex oue ꞇ yrcho. mufino ex cap̃ ꞇ ariete

M vsio
hun
qð captat. ı. uı
lumıuuſ noctı
t̃. ı. ıngenıoſ.

us pufıllı
latınũ fıt.

naicantur. Ham humuſ terra ꞇ m̃. ı. h
qðã marıtıma augent̃. q̃ ruꞇſ mınuu

M uſtela e
gũ dıct.
ıı habıt

locũ t̃nſfert. mutataq; fede locat. fer
eaꞇ gña t̃ Alca. H. fılueſtre dıſtanſ m

A large striped cat looks at a mouse. Illustration from a Bestiary, *c.* 1170.

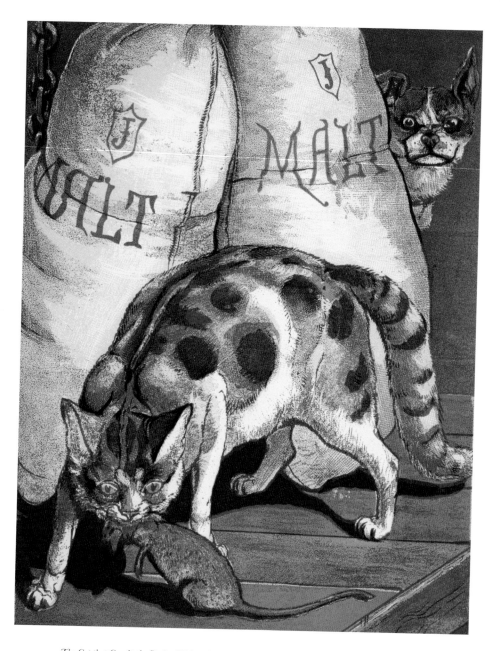

The Cat that Caught the Rat by Walter Crane from *The House that Jack Built*, edition of 1865.

Curly Locks? Curly Locks?
Wilt thou be mine?
Thou shalt not wash dishes
Nor yet feed the swine
But sit on a cushion
And sew a fine seam
And feed upon strawberries
Sugar and cream.

Ding dong bell Pussy's in the well.
Who put her in? Little Tommy Lin.
Who pulled her out? Little Tommy Trout
What a naughty boy was that
To drown poor Pussy-cat.

Ding, Dong, Bell, Pussy's in the Well from *The A, B, C of Nursery Rhymes* by Alfred J Johnson, 1892.

'I am the Cat who walks by himself,
and all places are alike to me.'

**Rudyard Kipling, *The Cat That
Walked by Himself***

The Cat that Walked by Himself from *The Just So Stories*, written
and illustrated by Rudyard Kipling, 1902.

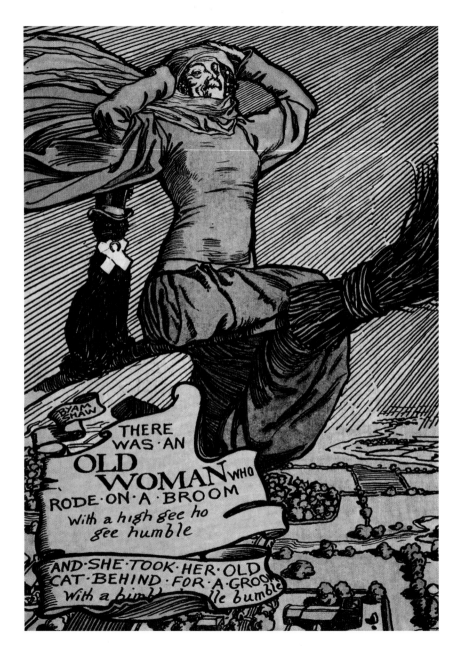

Illustration by Byam Shaw from *Old King Cole's Book of Nursery Rhymes*, 1901.

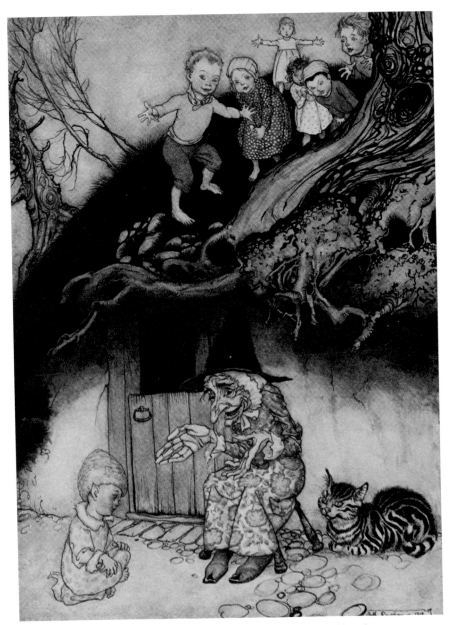

There Was an Old Woman Who Lived Under a Hill by Arthur Rackham from
Mother Goose, The Old Nursery Rhymes, 1913.

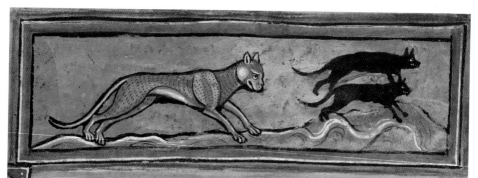

of est pusillum animal ex humore terre natum
cui iecur in plenilunio crescit. sicut quedam mari
ma augentur. que rursus imminente luna. deficiunt
est mus. indomitum animal et timidum. et quadrup
ex autem est mus maior. sic dictus. eoquod in modum
te predatur. vtriq; est musio infestus. Glires autem
ce videantur. mures non sunt. quia tota hieme do[r]
iunt et immobiles sunt quasi mortui. tempore estii
uiuisaute MO ris q̃ nomine. significatur terre
amans. uel ingluuie uentris. quia pro ingluuie
ris. mus nulla vitat piaila. Unde in leuitico et

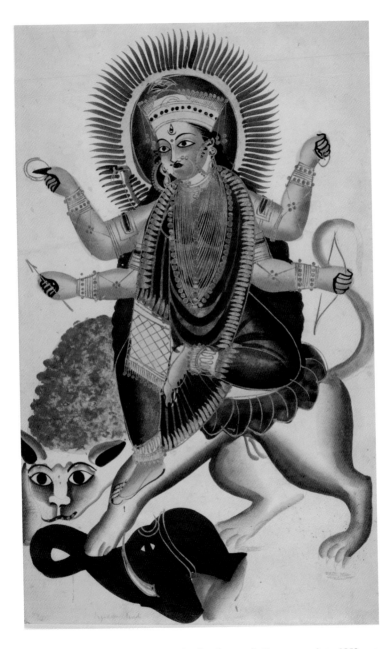

Durga as Jahaggadhatri riding on her lion from an Indian manuscript *c.* 1865.

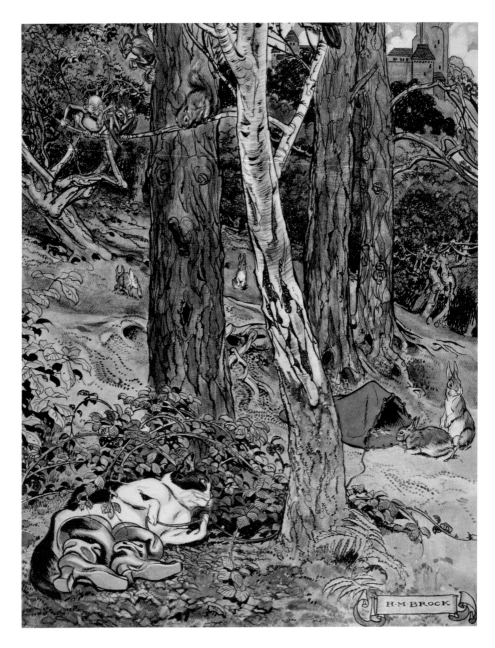

Puss in Boots from *The Old Fairy Tales*, pictured by H M Brock, 1913.

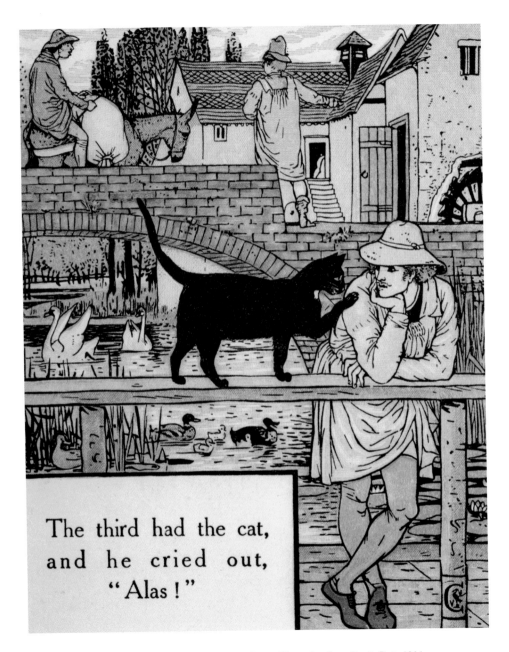

The third had the cat,
and he cried out,
"Alas!"

The Miller's Son and his Cat by Walter Crane. Illustration from *Puss in Boots*, 1914.

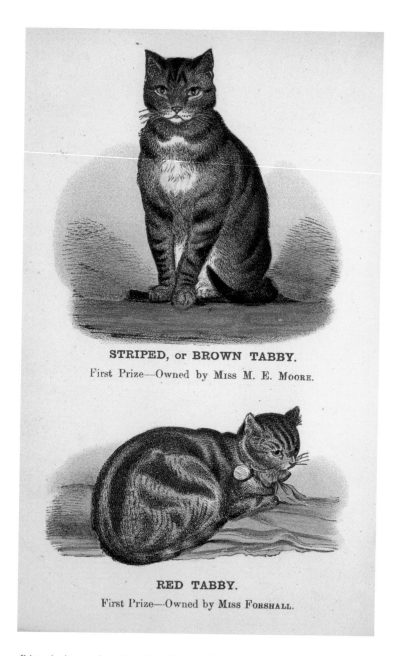

STRIPED, or BROWN TABBY.

First Prize—Owned by Miss M. E. Moore.

RED TABBY.

First Prize—Owned by Miss Forshall.

Prize-winning cats from *Cats: Their Points and Characteristics* by W Gordon Stables, 1876.

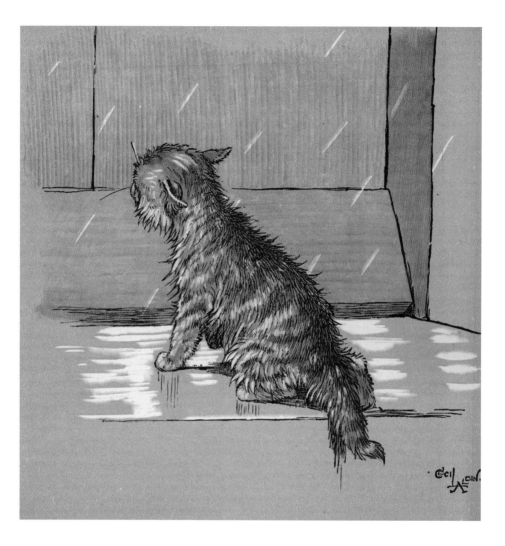

Out in the Rain from *The White Kitten Book*, written and illustrated by Cecil Aldin, 1909.

'A cat's got her own opinion of human beings.
She don't say much, but you can tell enough to make
you anxious not to hear the whole of it.'

Jerome K. Jerome

Illustration by Sogata from *The Tatler*, 13 March 1929.

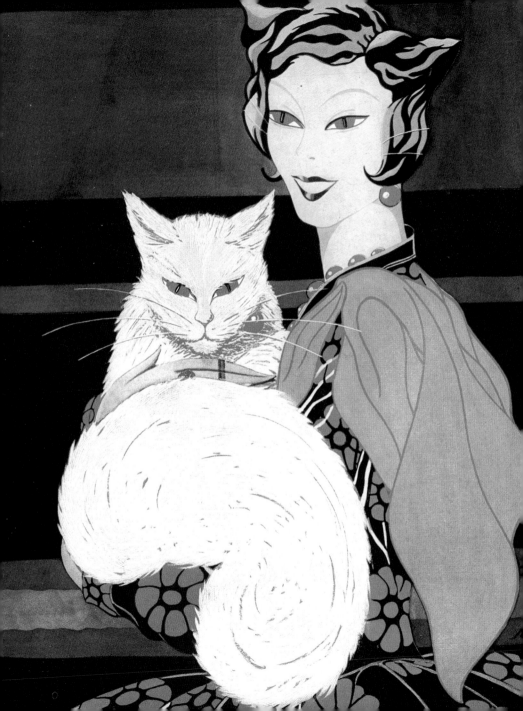

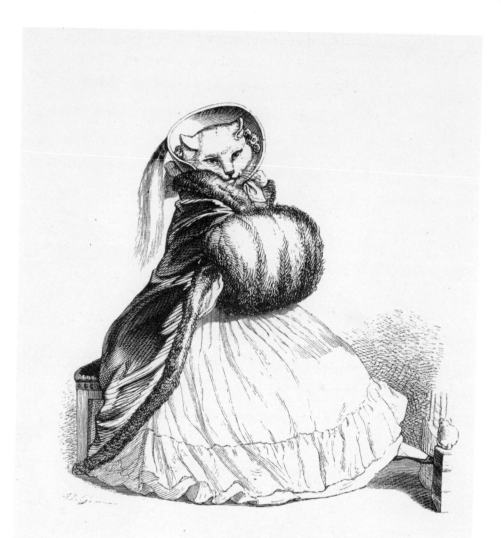

J'eus le manchon !....

The French Cat ('*La Chatte Française*') by J J Grandville from *Scènes de la vie privée
et publique des animaux* by P J Stahl, 1842.

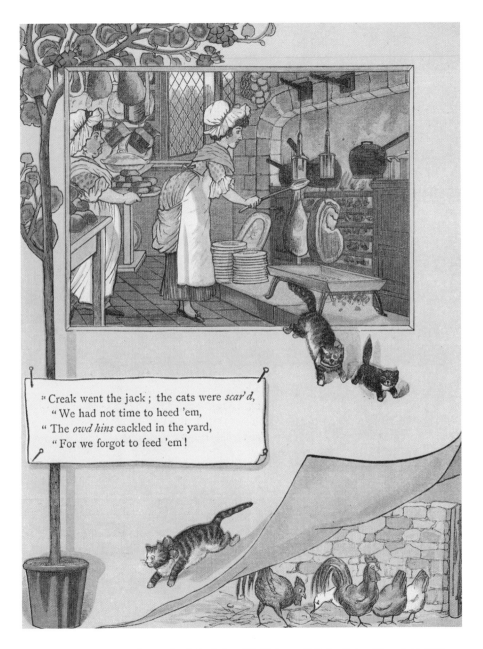

" Creak went the jack ; the cats were *scar'd*,
" We had not time to heed 'em,
" The *owd hins* cackled in the yard,
" For we forgot to feed 'em !

The Cats Were Scared by George Cruikshank from *The Horkey – a Ballad* by Robert Bloomfield, 1882.

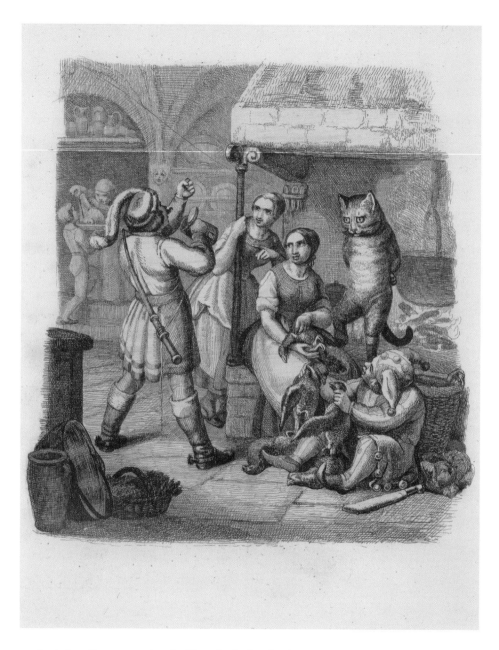

Puss in Boots. Copper engraving after illustration by Otto Speckter, *Das Märchen vom gestiefelten Kater*, 1843.

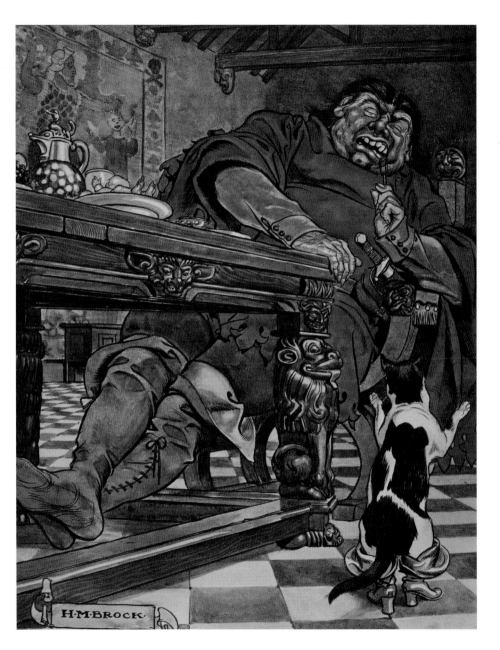

Puss in Boots from *The Old Fairy Tales*, pictured by H M Brock, 1913.

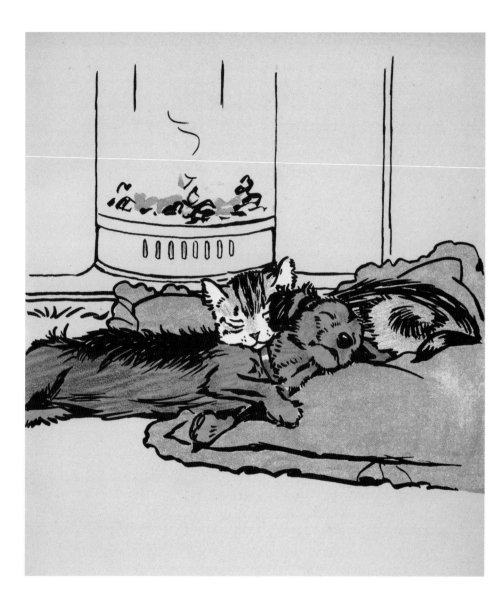

Jack and Jill at Home by Cecil Aldin from *Jack and Jill* by May Byron, 1914.

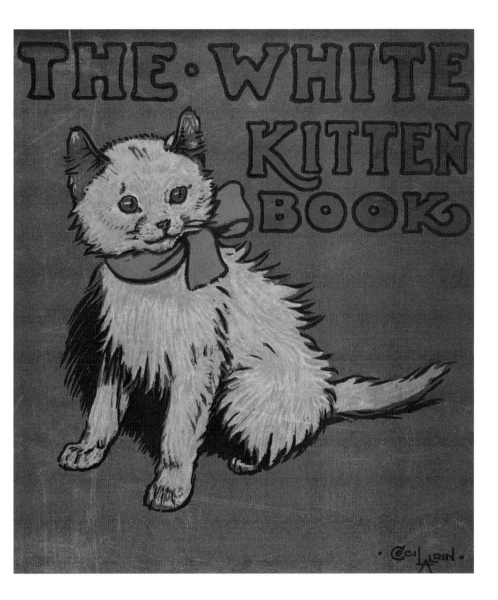

Front cover of *The White Kitten Book*, written and illustrated by Cecil Aldin, 1909.

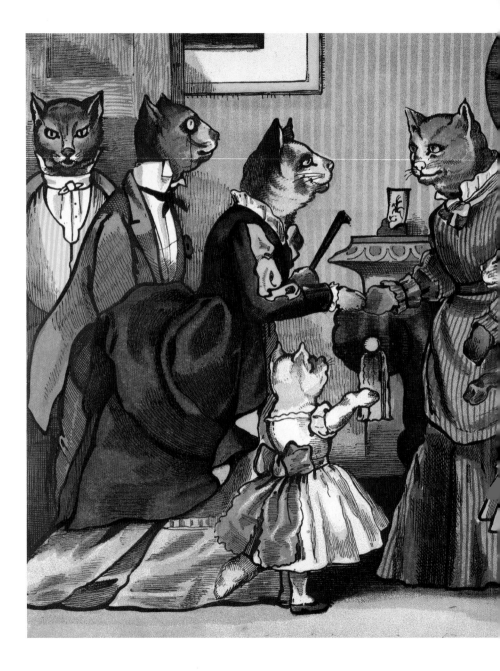

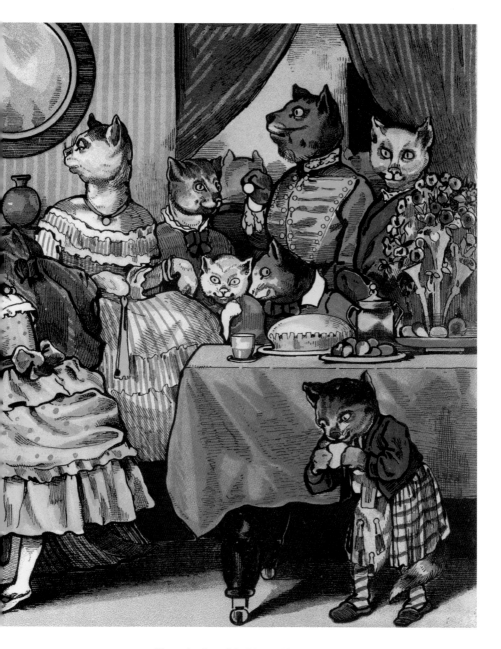

Illustration from *Miss Mouser's Tea Party*, 1876.

'The real objection to the great majority of cats
is their insufferable air of superiority.'

P.G. Wodehouse

Edouard Manet, illustration from *Les Chats*, 1870.

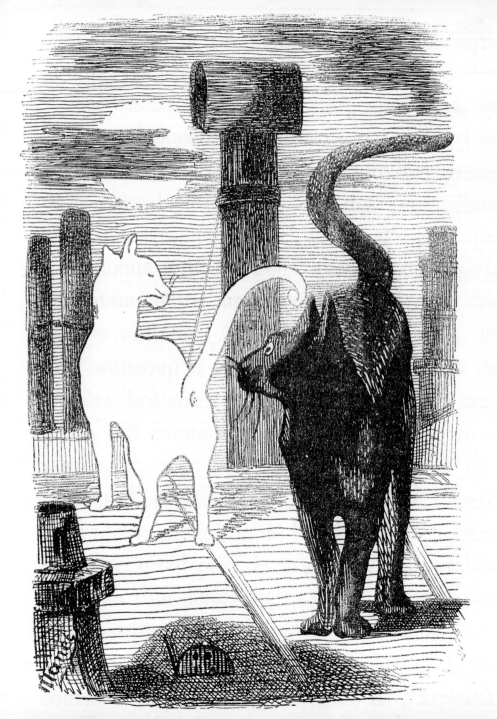

ARISTOTELIS
NATVRALIS AVSCVLTATIO-
NIS LIBRI OCTO NOVA RE
COGNITIONE EMEN,
DATI.

VENETIIS.

Title page of *Aristotelis Naturalis Auscultationis*, a sixteenth-century edition of Aristotle's writings on nature, 1546.

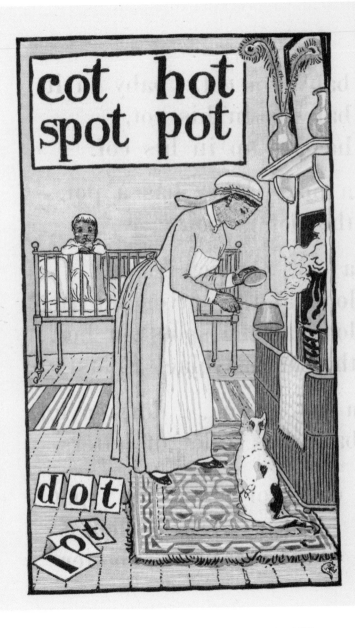

Cot, Hot, Spot, Pot from *The Golden Primer* by John Meiklejohn, 1884.

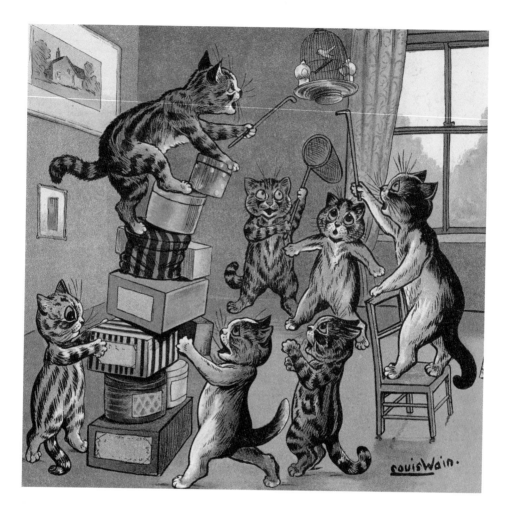

Attempts to Knock Down the Canary by Louis Wain from *Fun in Catland*, 1919.

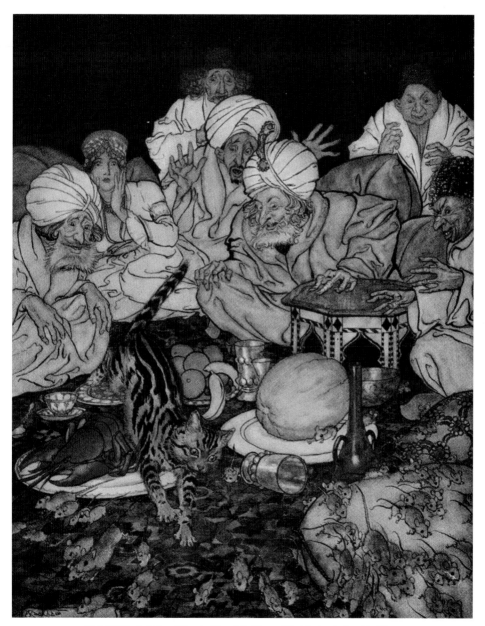

Dick Whittington's Cat ridding the King of the Moors of his Mice by Arthur Rackham
from *English Fairy Tales* retold by F A Steel, 1918.

Playing with String from *The White Kitten Book*, written and illustrated by Cecil Aldin, 1909.

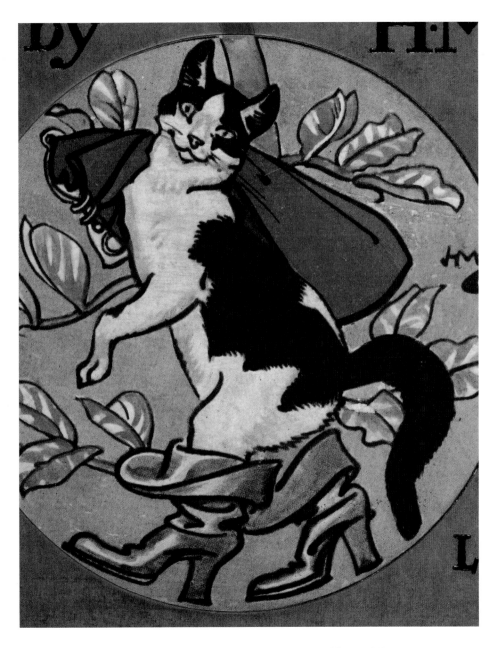

Puss in Boots from *The Old Fairy Tales*, pictured by H M Brock, 1913.

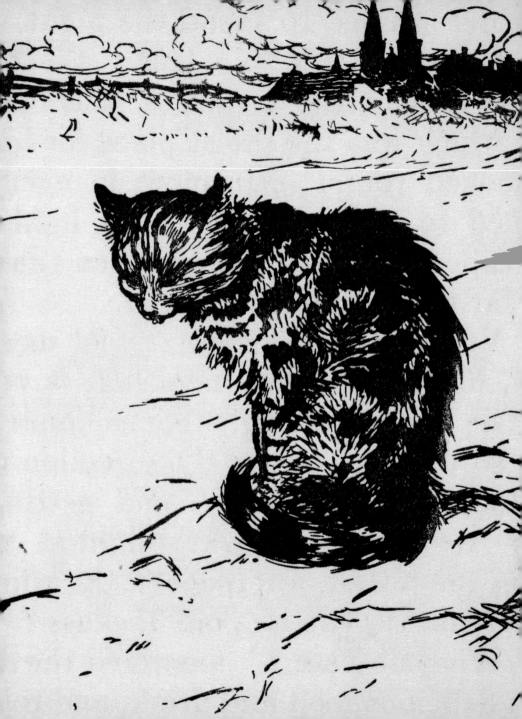

'The Cat is domestic only as far as suits its own ends; it will not be kennelled or harnessed nor suffer any dictation as to its goings-out or comings-in.'

Saki

Cat from *The Bremen Town Musicians* by Arthur Rackham from *Grimms' Fairy Tales*, 1925.

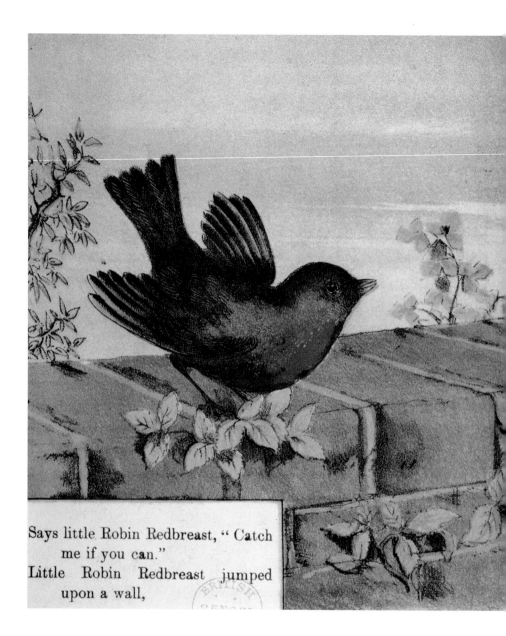

Says little Robin Redbreast, "Catch
 me if you can."
Little Robin Redbreast jumped
 upon a wall,

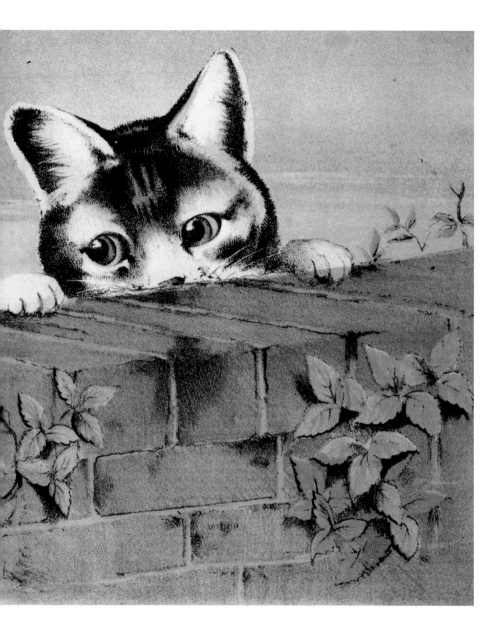

Says Little Robin Redbreast, 'Catch me if you can' from *Little Robin Redbreast*, 1881.

猫兒咬鳥

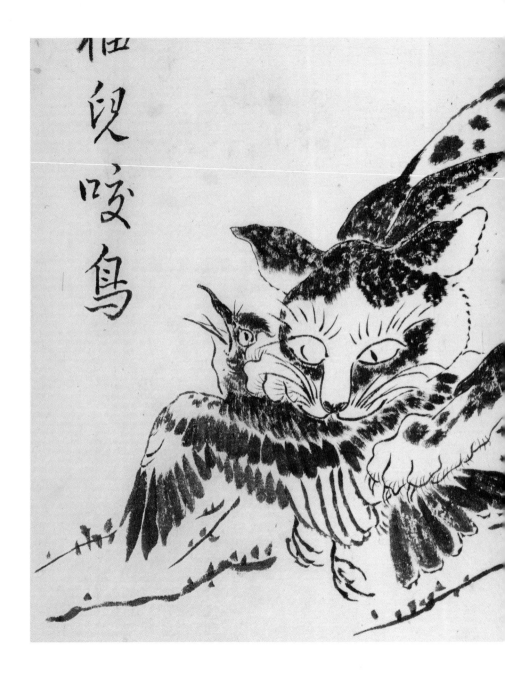

A Cat Pounces on its Prey from *Kanyosai Gafu ('The Drawing Book of Kanyosai')* by Tatebe Ryotai, 1762.

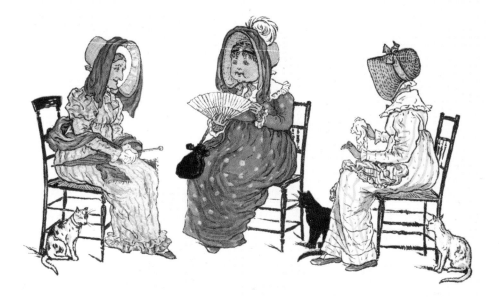

Three Tabbies Took Out their Cats to Tea from *Under the Window.*
Pictures and Rhymes for Children by Kate Greenaway, 1897.

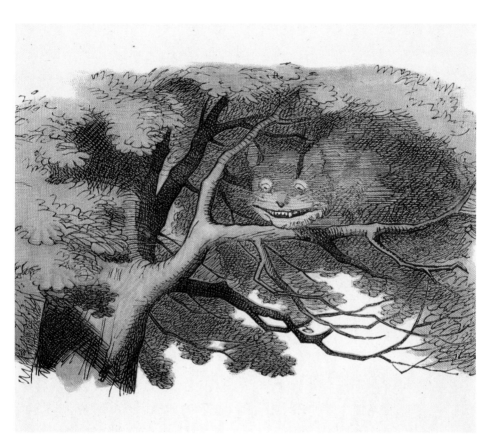

The Cheshire Cat by John Tenniel from *The Nursery Alice* by Lewis Carroll, 1890.

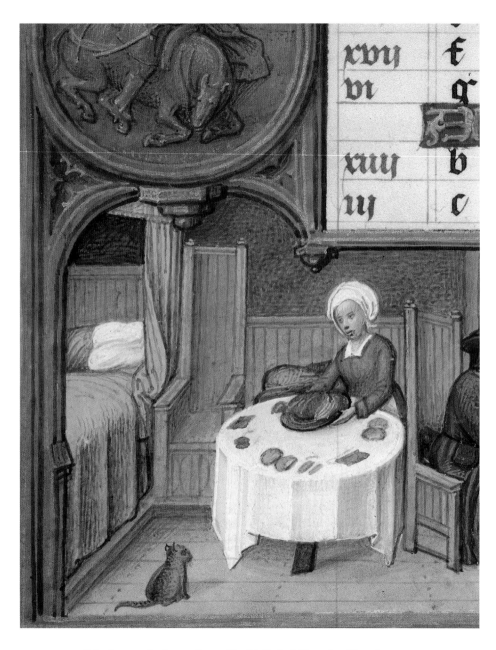

Calendar scene for January from a Flemish Book of Hours, late fifteenth century.

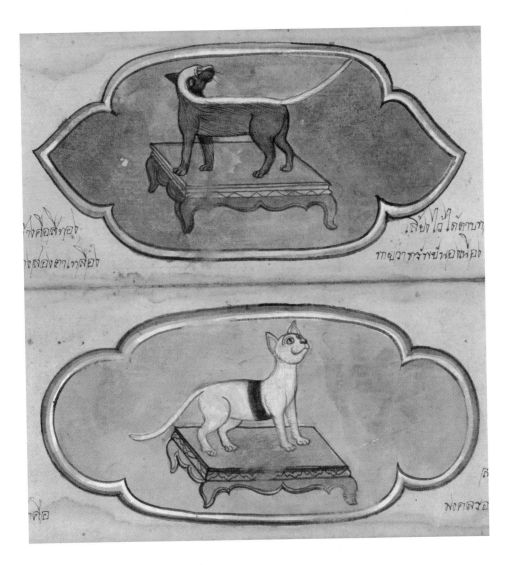

Siamese Cats from a Thai manuscript of the nineteenth century.

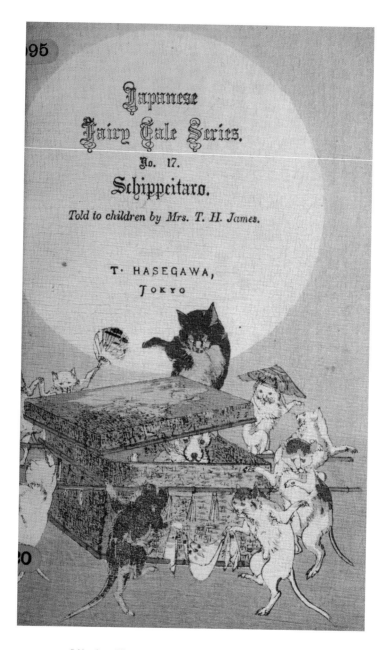

Japanese
Fairy Tale Series.
No. 17.
Schippeitaro.

Told to children by Mrs. T. H. James.

T· HASEGAWA,
TOKYO

Schippeitaro. Illustration from *Japanese Fairy Tale* series, 1905.

Taking a Nap from *The White Kitten Book*, written and illustrated by Cecil Aldin, 1909.

'The cat is a dilettante in fur.'

Théophile Gautier

A grey cat playing a rebec from an English Book of Hours, *c.* 1320–30.

laudabit dominum ·

Quia prospexit de excelso!

sancto suo: dominus de ce

lo in terram aspexit.

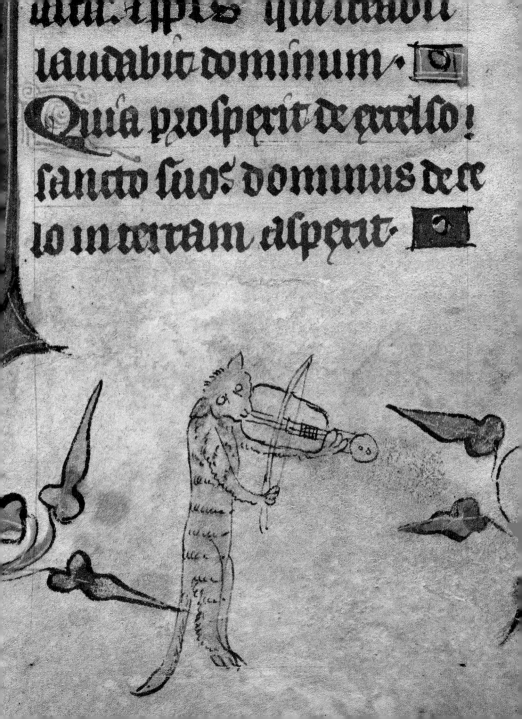

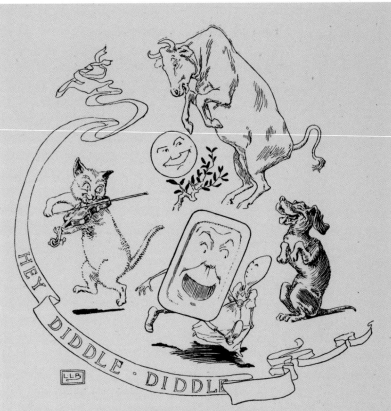

HEY! diddle, diddle,
The cat and the fiddle,
The cow jumped over the moon;
The little dog laugh'd
To see the sport,
While the dish ran after the spoon.

Illustration by L Leslie Brooke from *The Nursery Rhyme Book*, 1897.

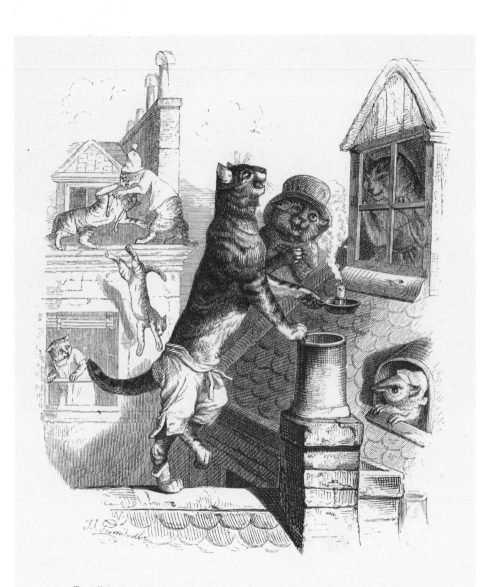

Tous l'aimaient éperduement, et passaient les nuits et les jours sous ses fenêtres dans l'espoir de toucher son cœur, mais......

Cries of the Heart of a French Cat (Peines de Coeur d'une Chatte Française') by J J Grandville
from *Scènes de la vie privée et publique des animaux* by P J Stahl, 1842.

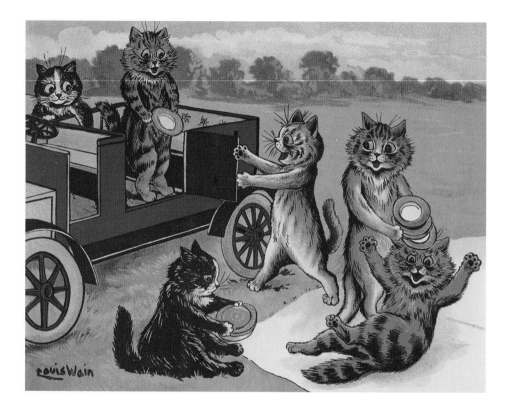

Picnic Time by Louis Wain from *Fun in Catland*, 1919.

PUSS IN BOOTS.

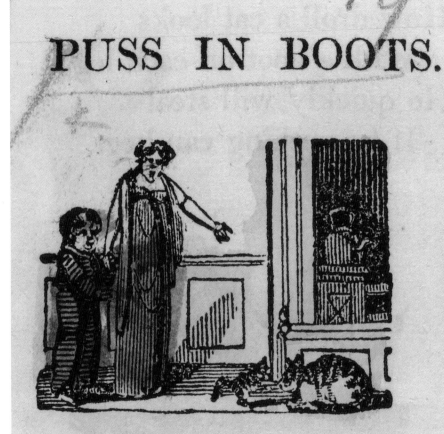

In day-light cat and kitten play,
At night puss frights the mice away.

Title page of *Puss in Boots*, 1830.

'I am as vigilant as a cat to steal cream.'

Shakespeare, *Henry IV Part I*

Frontispiece illustration of a cat and a mouse for *Opere Toscane*, Luigi Alamanni, 1533.

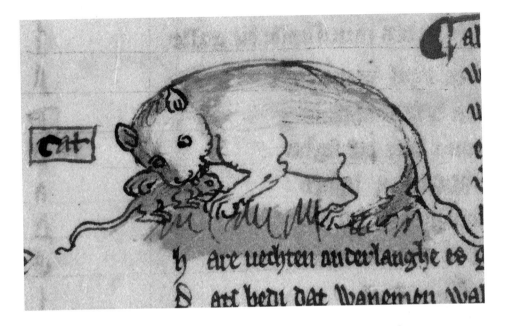

Cat eating a mouse from a Dutch translation of *De Natura Rerum* by Thomas de Cantimpré, thirteenth century.

C is the Cat, roaming 'round
in the night,
How he shrieks in his anger,
"Come on, and let's fight."

D is the Dog that is
watching my yard,
He looks like
a soldier who's
standing on guard.

Illustration from *Denslow's One Ring Circus and Other Stories* by W W Denslow, 1903.

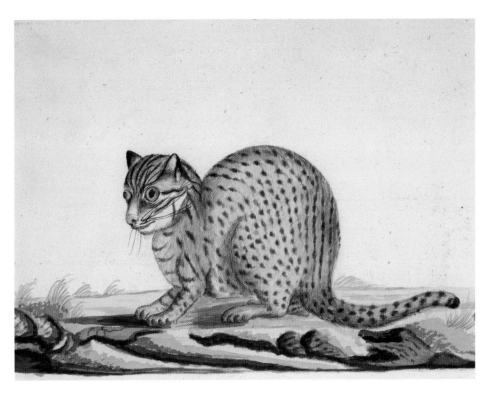

A spotted wild cat, poised to spring.

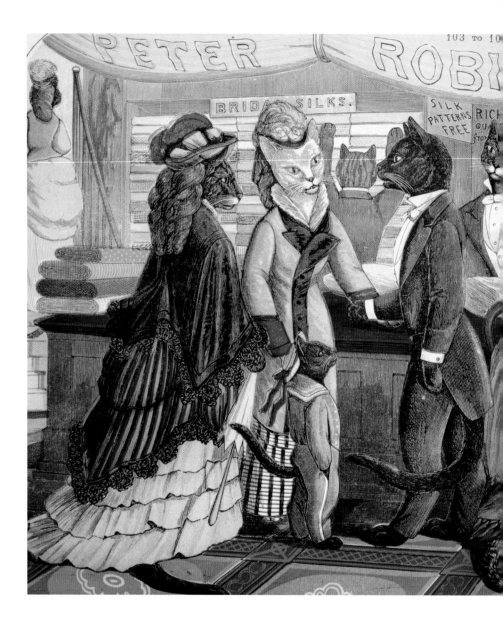

Miss Tortoiseshell at Peter Robinson's Selecting her Bridal Costume from *Pussey's Wedding*, 1876.

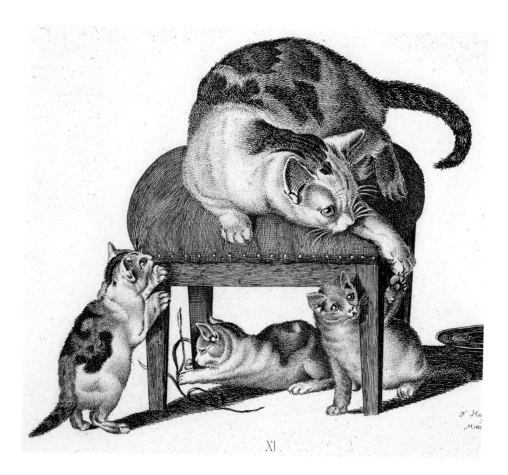

Illustration by Gottfried Hind from *Der Katzen-Raphael* by Franz von Gaudy, 1861.

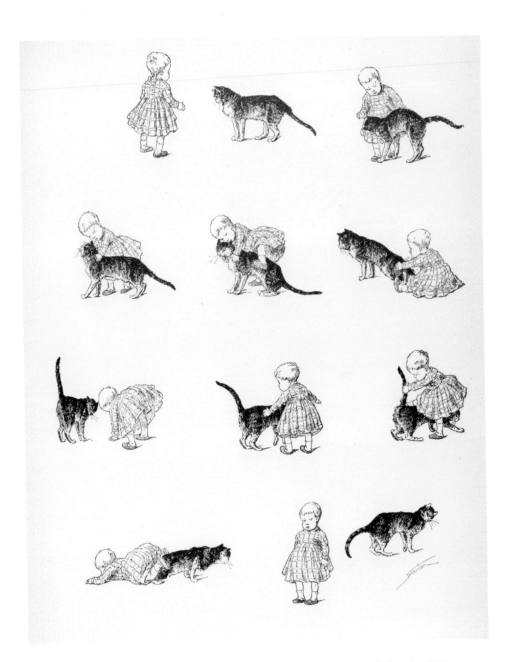

A Child and her Cat from *Des Chats, Images Sans Paroles* by Théophile-Alexandre Steinlen, 1897.

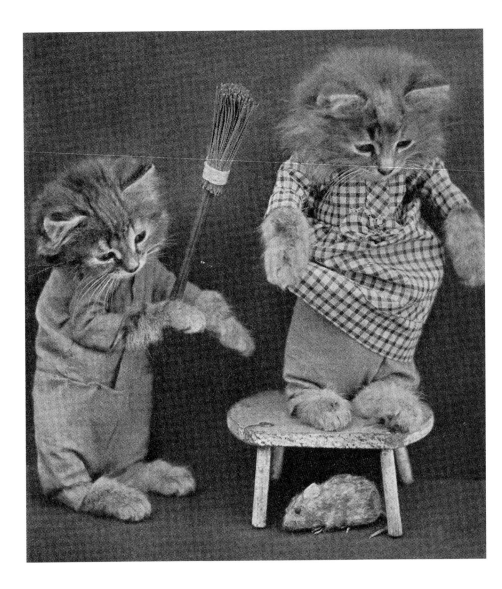

Dealing with a Mouse from *Four Little Kittens*, written and illustrated by Henry Whittier Frees, 1934.

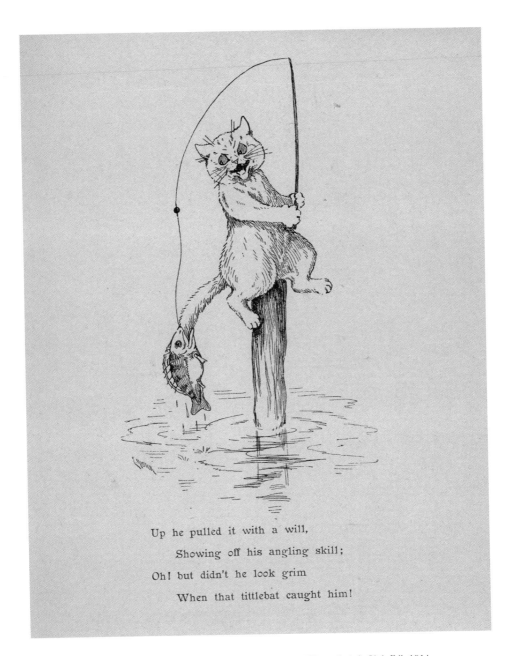

Up he pulled it with a will,

Showing off his angling skill;

Oh! but didn't he look grim

When that tittlebat caught him!

A Fishing Story by Louis Wain from *A Cat Alphabet and Picture Book for Little Folk*, 1914.

Title page of *Pussey's Wedding*, 1876.

C

C was a Cat
Who ran after a Rat,
Whose courage did fail
When she seized on his tail —
 C!
Angry old Cat!

Edward Lear from *Rhymes of Nonsense: an Alphabet*, 1862.

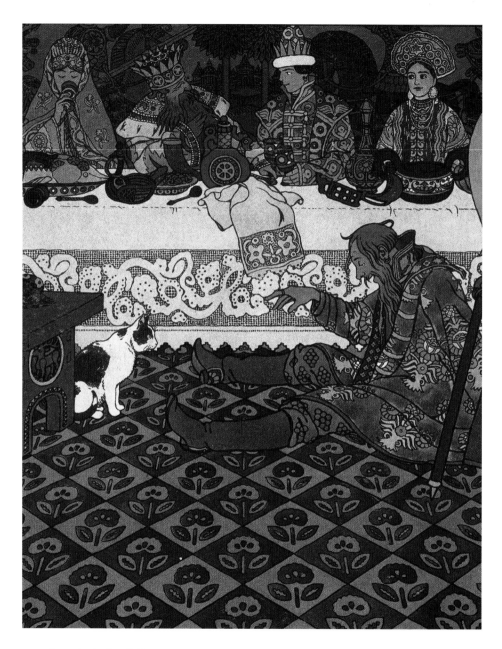

Illustration by Ivan Bilibin for a 1905 edition of *The Tale of Tsar Saltan* by Alexander Pushkin, 1831.

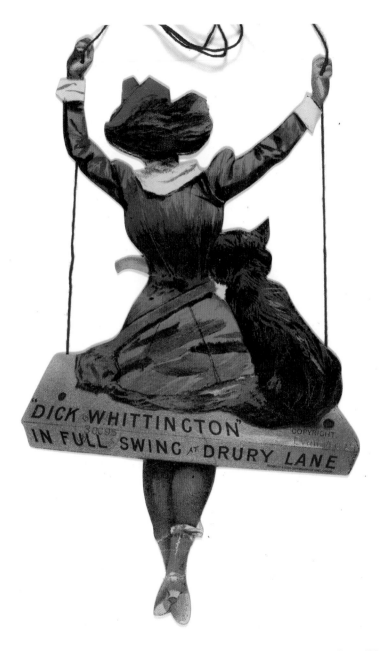

Advertising novelty for the pantomime *Dick Whittington* at the Theatre Royal, Drury Lane, 1894–5.

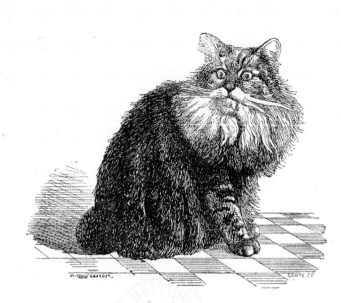

Victor Hugo, illustration from *Les Chats*, 1870.

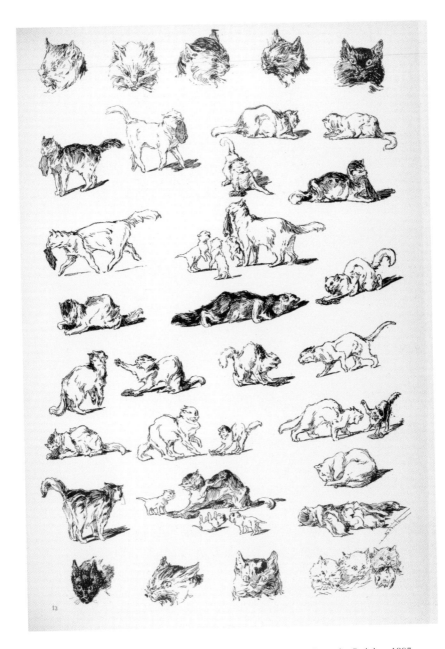

Cats at play from *Des Chats, Images Sans Paroles* by Théophile-Alexandre Steinlen, 1897.

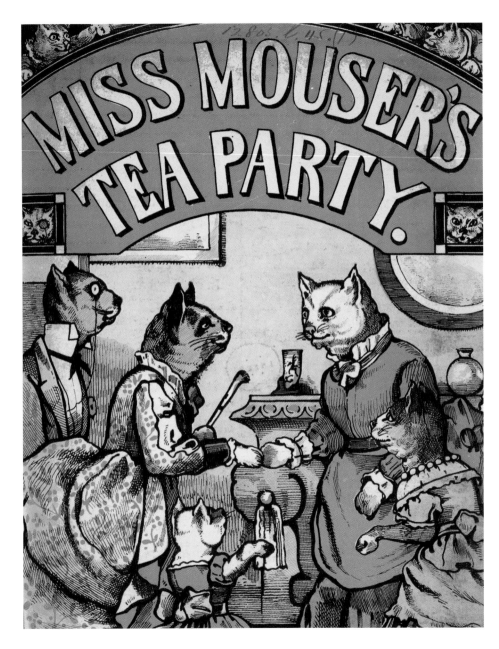

Title page from *Miss Mouser's Tea Party*, 1876.